Experimental Corsets

Val Holmes

BATSFORD

Published in 2016 by
Batsford
1 Gower Street
London WC1E 6HD
An imprint of Pavilion Books Company Ltd

ISBN: 9781849943444

A CIP catalogue record for this book is available from
the British Library.

20 19 18 17 16
10 9 8 7 6 5 4 3 2 1

Reproduction by Colourdepth, UK
Printed in China by 1010 Printing International Ltd.

This book can be ordered direct from the publisher
at the website: www.pavilionbooks.com, or try your
local bookshop.

Distributed in the United States and Canada by
Sterling Publishing Co., Inc. 1166 Avenue of the
Americas, 17th Floor, New York, NY 10036.

Used for the last 400 years to contort the female body into a variety of fashionable silhouettes, the corset has become a fascinating and hugely popular motif for modern textile artists who wish to represent the female body, often subverting the traditionally feminine traditions of textile and stitch in exciting and unusual ways.

Beginning with ideas for simple and wearable fabric corsets, the book goes on to explore more contemporary and experimental approaches to construction, from using materials such as lace, metal, paper and found fibres to up-cycling or repurposing existing garments to make a statement.

This practical guide is full of exercises for creating intimate garments and wearable art in two- and three-dimensions and is packed with inspiring work and installations by the author and other contemporary artists.

Experimental Corsets

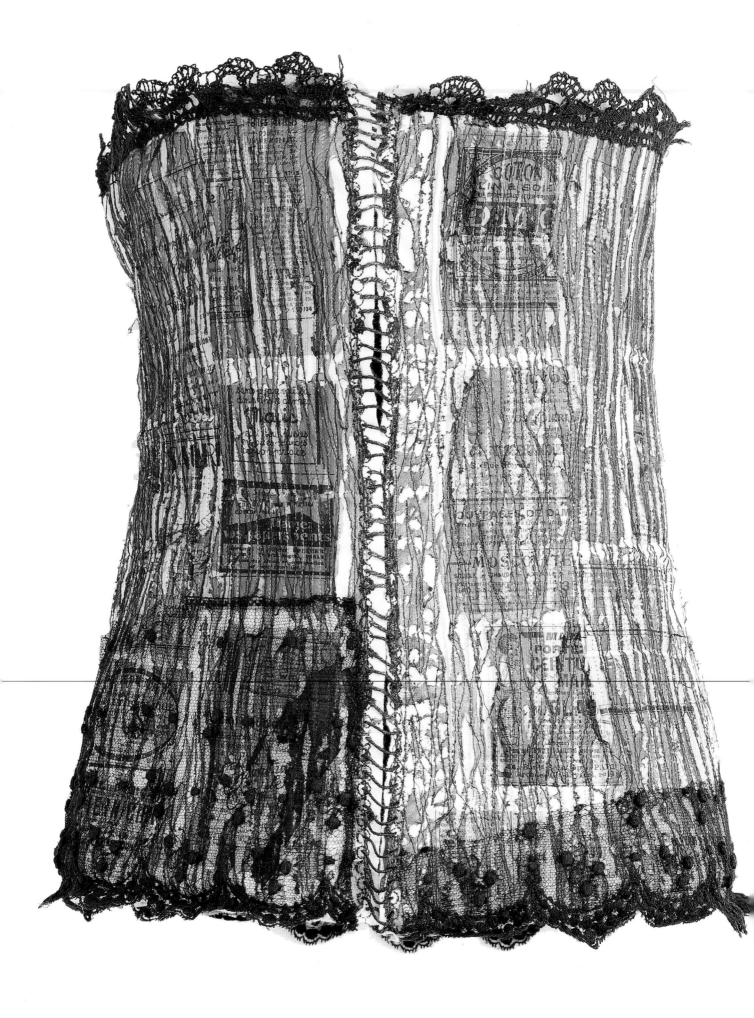

Contents

Preface

When I started producing sculptural corsets some years ago I was pretty convinced that my relationship to these pieces was that of a feminist making statements about women's confinement or, on the contrary, their liberty. As time moved on each corset arrived through a new technique idea that I would attribute to an invented or historical character. But I also became aware that the corset making was very much to do with my relationship with my own body. My over indulgence in house renovation has taken its toll on my back and I frequently wear a support corset when installing exhibitions, gardening and so on, and the periods when I find myself in the support corset relate to the times when I suddenly get the urge to create another more beautiful and sexy version. It is this revelation that led me to realize that a lot of women's art about the body is very personal, which is something to be built on rather than denied. Finally, in a response to this, I took an old white support corset and turned it into the sort of coloured corset that I would prefer to wear!

This book has evolved beyond corsets to include all sorts of wearable art, unwearable art, and even 'underwearables' in a response to these most intimate of garments that we hide and that hide us. The garments that we use to preserve our modesty and cover our desires. Or the garments that abandon our modesty, reveal our dreams and awaken desire.

Our relationship with these undergarments is often confused. It lies somewhere between Victorian pruderies that suggest even to name such garments could be considered unchaste, the feminist denial scenario in which all overtly sexualizing body covers could be considered the trappings of gender stereotyping that help to maintain women's inferior social position, and covert or overt sexual fantasies in a new feminist approach that encourages us to take control of our bodies and how we want to picture them. Although of course this latter approach is also full of traps and pitfalls positioned by existing views and dogma.

In order to steer a path through this minefield of preconceived ideas, or innovative positioning, any artist needs to rely on her own reflections and the relationship she has with her own body – and body coverings – to project her ideas through the work she creates. Looking at the way other artists have approached this may help you to engage in useful responses.

This altered back support by Val Holmes was first coloured with Procion dye then decorated with appliqué, machine embroidery with feather stitch, whip stitch and cable stitch. Shisha glass applied with machine feather stitch gives the finishing touches.

Introduction

From the first bands of cloth surrounding the midriffs of Egyptian slaves that were copied by the upper classes, the appearance of female underwear may have come a long way, but its function has changed little throughout the millennia. Underwear has three functions that vary in their importance according to the morality of the times: to hide modestly what it covers; to expose immodestly what it does not cover; and, in many periods of fashion, to completely alter, or at least attempt to control, the actual shape of the wearer.

Burnt Corset by Val Holmes. Fine steel fabric coloured using a gas flame was stitched on to a heavy plastic bin liner and heated to create a light quilting effect. The sides are layered polyester organdie, stitched and heat tooled to create a lace effect. See page 67 for more details.

In *Corsets and Crinolines* by Norah Waugh (1954), the author suggests that unlike a man, who led a more active life and whose dress had to take this into consideration, a woman, or at least a lady of leisure, was able to adopt any style of clothing and, ignoring almost all restrictions, could exaggerate line and shape and push style to the limit until she found herself 'unhesitatingly encased in whalebone, cane and steel to achieve the desired silhouette, and then later, to attune herself to a changing world, just as unhesitatingly discarded all these artificial props.'

Waugh suggests that 'This over-emphasis of line has given a curious underlying rhythm to women's clothes and become an unwritten law of design. A long slender silhouette begins to widen at the base, emphasis shifts from length to breadth, and when the greatest circumference possible has been reached, there is a collapse, a folding up, and a return to the long straight line.'

Writing in 1954 she argues that there have been three such cycles in the preceding four centuries; 'each time the artificially widened skirt had to be balanced by a small artificially shaped body, each time the silhouette was different, and each time the names changed too; first, the whaleboned-body and the farthingale, second, the stays and the hooped petticoat, third, the corset and the crinoline.'

Interestingly her theory of oscillation between large exaggerated shapes, reduced to fine lines and then back again, has continued to be observed in fashion since the first publication of her book: from the billowing dresses and small waists of the late fifties to the boyishly straight lines of the late 1960s, beyond which things seem to have sped up and got out of control; the extremes are still there in fashion, though now often simultaneously.

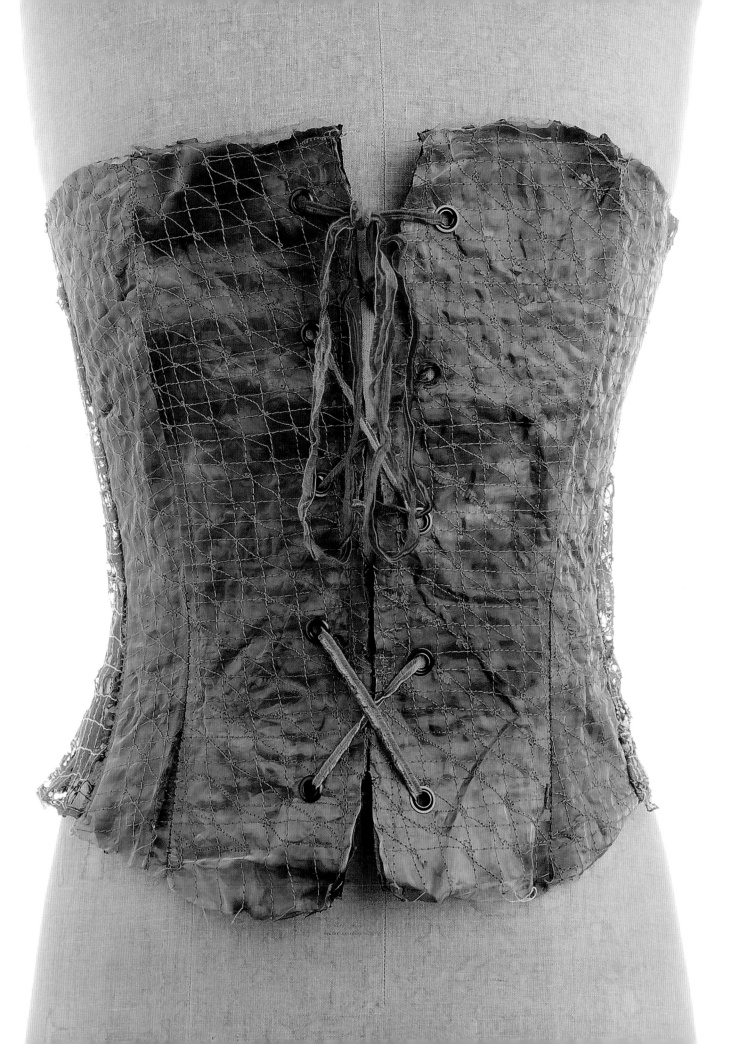

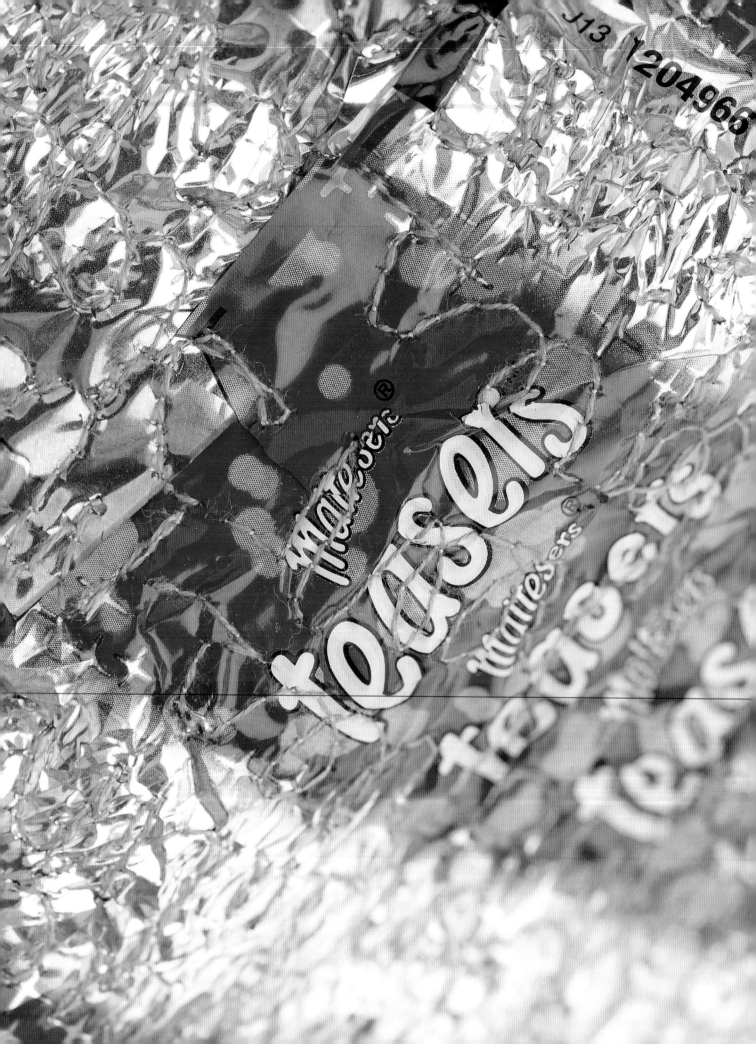

Working with the body

It is this simultaneity of clothing shapes that perhaps gives us our confused vision of 'perfect' body size and shape. In the past the 'ideal body' was rather easily defined by a fashion that would have some longevity and which would set the norm for the period. Women would struggle to achieve this body shape through diet or physical constraints in order to appear attractive in their particular era.

At a time when the peak of fashion is more ill-defined, and the norms of the perfect body unattainable and fictitious (thanks in part to Barbie and Photoshop), foodie culture, food availability and systematic over-eating have led to an appreciation, not only of the fuller figure, but also of the extremely large figure. What is deemed acceptable in body shape seems to be reproduced in the simultaneity of fashion and clothing shapes, leading to a crisis for many in the way they see their bodies.

But can feminist anger at the vision of anorexic-looking top models, Barbie-doll imagery and the overuse of Photoshop really justify over-consuming to the point of becoming clinically, dangerously, overweight? As the acceptance of the more-than-fuller figure is becoming the norm, could this be seen as the contemporary interpretation of Waugh's theory that the female body moves between the extremes of the slender figure and the 'greatest circumference possible'? The issues are numerous and complicated and create a malaise in our relationships with our bodies and how we perceive them.

The discussion of our relationship with the female body in general or with the individual artist's body in particular has been the subject of much feminist art in the last half century. Bearing in mind that the female body has been a subject of predilection for male artists for centuries, many female artists have deliberately attempted to re-conquer this space in art as rightfully theirs to comment on and explore in all its intimacy.

The notion of how we (and others) see our bodies, and how this relates to the clothing and undergarments that we adorn ourselves with, has become an important subject for many female artists and textile artists.

Slave to Chocolate (detail) by Val Holmes. The chocolate wrappers are appliquéd to the base fabric of the corset alongside quotes about the quality and dangers of chocolate and comments about the current use of slavery in the production of chocolate in some areas of the world. The complete corset is shown on page 69.

11

We are what we wear

Another fruitful area of research for the textile artist lies in the notions that we are what we wear or that we wear what we are.

In the first place we are what we wear, or can even become what we wear. The clothes or dress code chosen may at first seem to be some sort of disguise. We dress up as the bright schoolgirl we wish to be, or choose consciously the attire of the successful office worker or manager. The clothes are there to tell others what we are, even if inside this feels a long way from the truth, and we wish or need to hide behind the façade. The disguise may become the reality, but at first the person inside is only pretending, wearing a complicated mask. Dressing up to go out and wearing make-up is another aspect of disguise and the choice of underclothes that underpin all this may also form a part of the whole.

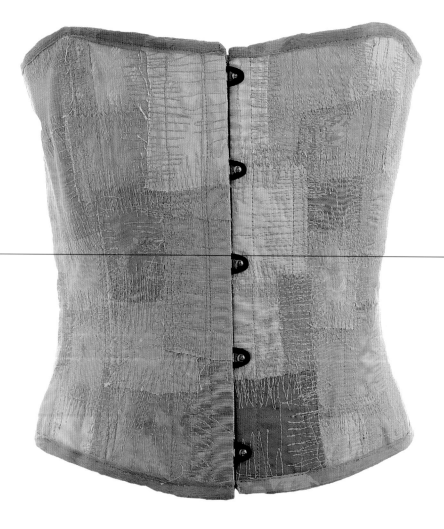

Nana's Corset by Val Holmes. Appliqué with free-motion embroidery. A wearable corset. See page 54–57 for details.

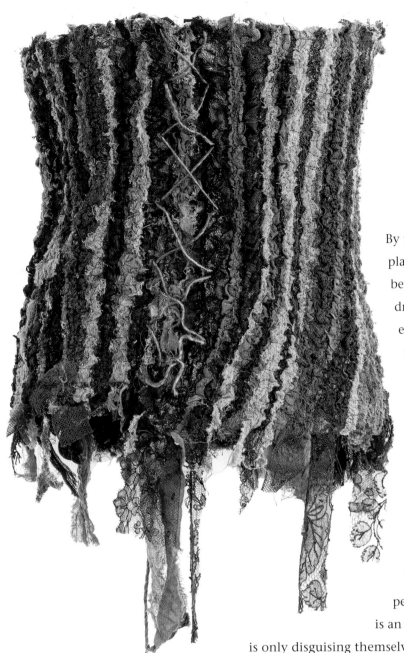

La Maison Close (The Brothel Corset) by Val Holmes. Worked with black lace and dyed cotton scrim on hot-water soluble fabric, then shrunk with cold water. Formed with corset boning. See *The Bride's Corset* on page 19 for more details.

By using dress codes in this way we play at some sort of fancy-dress game, becoming the character of the fancy dress while in the disguise, and perhaps eventually losing the original person to become the chosen character permanently. What is left when the mask is taken away is another area of contemporary crisis.

In the second place we wear what we are. The clothes and the look don't even seem to have been chosen. They arrive and seem to suit so much that they are part of the person and define the person. There is no element of disguise. The person may exaggerate aspects but there is an underlying feeling that the person is only disguising themselves as themselves. The result may be quite positive and interesting, but may also be negative and boring, creating the need for a new disguise in another dress code.

The notion that the clothes define the person or that the person has defined their clothes out of choice to hide a reality or as a wish for disguise or character enhancement can be used as a springboard for creation. Wearable or unwearable art created to define a fictitious or named character pulls its strength from the arguments above. One could imagine that it is in the intimate garments the person wears that the definition of the intimate character is at its most real and truthful, and it is perhaps for this reason that a large number of artists address this type of clothing.

13

The corset in art

The corset can offer an interesting area of study for the textile artist who wishes to evoke a character through conceptual dress, perhaps over and above other types of clothing. This is because, in a sense, it encompasses both of the above arguments: we are what we wear and we wear what we are. The character chosen by the artist may well define the corset and its appearance, but the corset defines the body and the final way in which the body will look. There is therefore a double constraint placed on the conceptual character that we can feel when looking at the corset: that of a defined appearance that must be adhered to as well as the defined – and confined – body shape.

Clothing as art

Wearable art or art that is wearable is an area that textile artists continue to exploit. It is important here, perhaps, to discuss the difference between beautiful clothes, that may even use eccentric techniques, and clothes that have a real statement to make as pieces of art. There is a difference, and one should be aware of it. These days it's not just beauty that makes something art! Having said that, I loved the banner at a Venice biennial that insisted 'It doesn't have to be ugly to be art'. The tension between art and craft, with their inherent, sometimes unjustified hierarchy, will always be with us. The current view would seem to be that content, or conceptual content, is what can make the defining difference; placing something as art because of conceptual content. Thus the end result justifies the means employed rather than the means leading to an end. That is to say that once the statement or concept has been decided upon by the artist, the work will follow a pattern using the necessary techniques in order to express the idea, rather than a work being technique led. That said, we are textile artists and embroiderers who love technique, so why shouldn't we enjoy this too!

The final piece created to explore a concept may therefore be three-dimensional and wearable, but equally may be a sculptural reference to clothing that is actually unwearable, either through the materials chosen or perhaps the scale of the work; being either too small or too large.

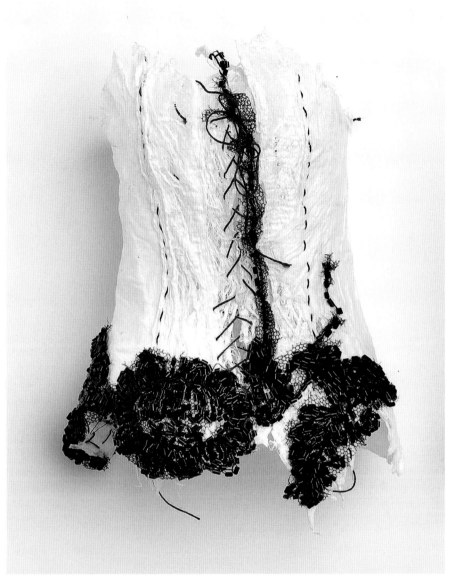

Mourning, a miniature mulberry-paper corset by Val Holmes.

The final piece may be two-dimensional and simply reference an article of clothing rather than being made to wear. The object is flat and presented as such, referring to parts or the whole of a garment simply by its outline and shape, or the use of sewing notions such as buttons, zips or other closures.

In all cases the palpable presence of the wearer, the suggestion of the body enclosed by the garment or the distinct absence of the body within or underneath the work forms part of the statement and part of the strength of the piece. To work with clothing in art is to work with the body or its pertinent absence, and it is the consciousness of this that will help to make a piece of work successful.

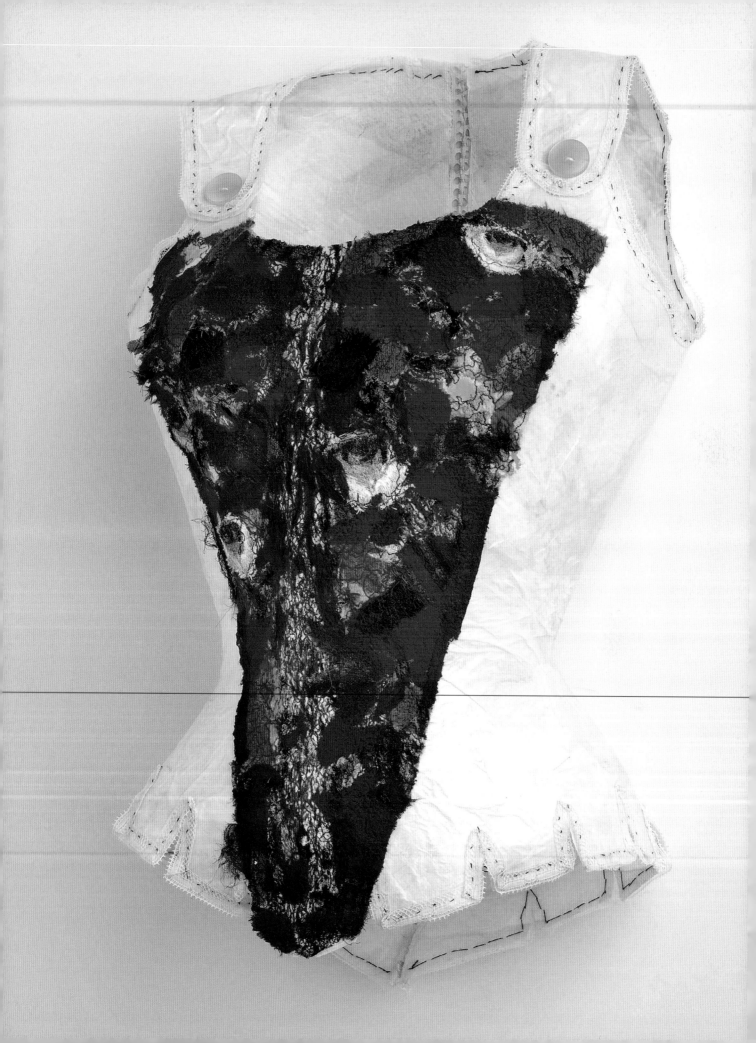

The Bride's Secret Garden is an embellished paper corset on a Lutradur base.

Three-dimensional Sculptural Corsets

Corsets as art pieces are very often unwearable, and this is usually because the materials chosen are just not practical to be worn. If the piece is not meant to be worn, then the way in which it is to be displayed has to be addressed.

Approaches to modelling and display

In the introduction I discussed the idea that artwork based on clothing is inevitably also about the body, and it is this reference to the presence or absence of the body that can give clues to how such pieces may be displayed, and therefore the design necessary to allow the chosen display method to function.

I would suggest that globally there are two methods of displaying three-dimensional unwearable clothes and corsets, and that is very simply the presence or absence of a representation of the body.

In the first instance some sort of dummy or mannequin could be used as a support to represent the body as a presence. The mannequin could also be worked upon and become part of the piece, or it could be quite simple, a faceless plastic body that almost implies absence, or at least an absence of person, even if the physical body is present. The use of a mannequin may imply ownership of the corset, as in a shop or museum where the body inside is necessarily not that of the spectator.

In the second instance the garment or corset is allowed to define the space from which the body is absent by using some sort of pedestal, or creating a means of hanging the corset or garment in the air. The artwork of the corset stands on its own, but its shape can be more easily perceived, and the exaggeration of form or thinness more easily appreciated. The absence of the body will implicate the spectator further into the piece, transferring her own body into the space that has been left with the impossibility, discomfort or eroticism that this action implies. The result may be even more destabilising: the mannequin represented a real woman, and now nothing is represented except some imaginary concept. Dangerous ground for the sexual imagination.

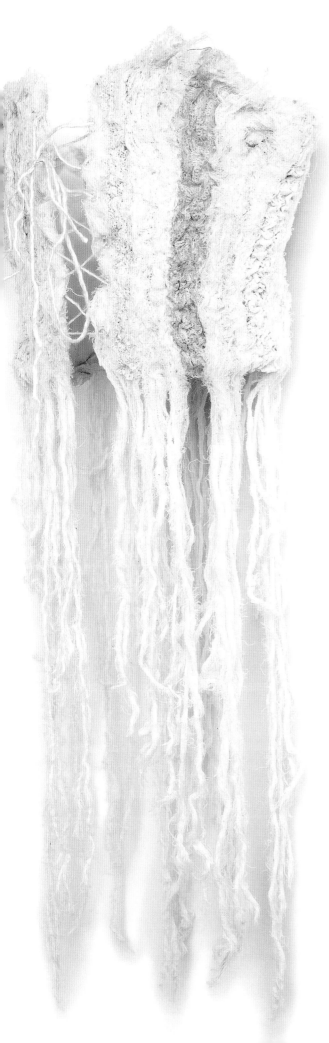

Textile sculptural corsets

Although it may seem quite automatic to make a textile-based corset wearable, there are materials, inclusions or methods of construction that preclude this possibility. The following considerations should be taken into account when choosing if a textile corset is to be a sculptural or wearable item.

The choice of materials

Certain fabrics may be difficult to clean or too delicate to be worn. The fabric used for the construction method itself may pose a problem. *The Bride's Corset*, shown left, is constructed on hot-water soluble fabric that has been sprayed with cold water instead of being dipped in hot water. This causes the hot-water soluble fabric to shrink, causing ripples in the fabrics that have been stitched to it. If left in water the soluble fabric will simply disappear and the shrinking effect with it. Furthermore, *The Bride's Corset* is modelled onto chicken wire and then lined in order to keep its shape, so it is completely unwearable. Similar effects can be achieved by heating certain plastics with a heat gun. The plastic would be unpleasant to wear, but a lining could be used to allow for the piece to be worn.

The Bride's Corset by Val Holmes, made from machine-stitching cotton scrim and lace onto a shrinking fabric.

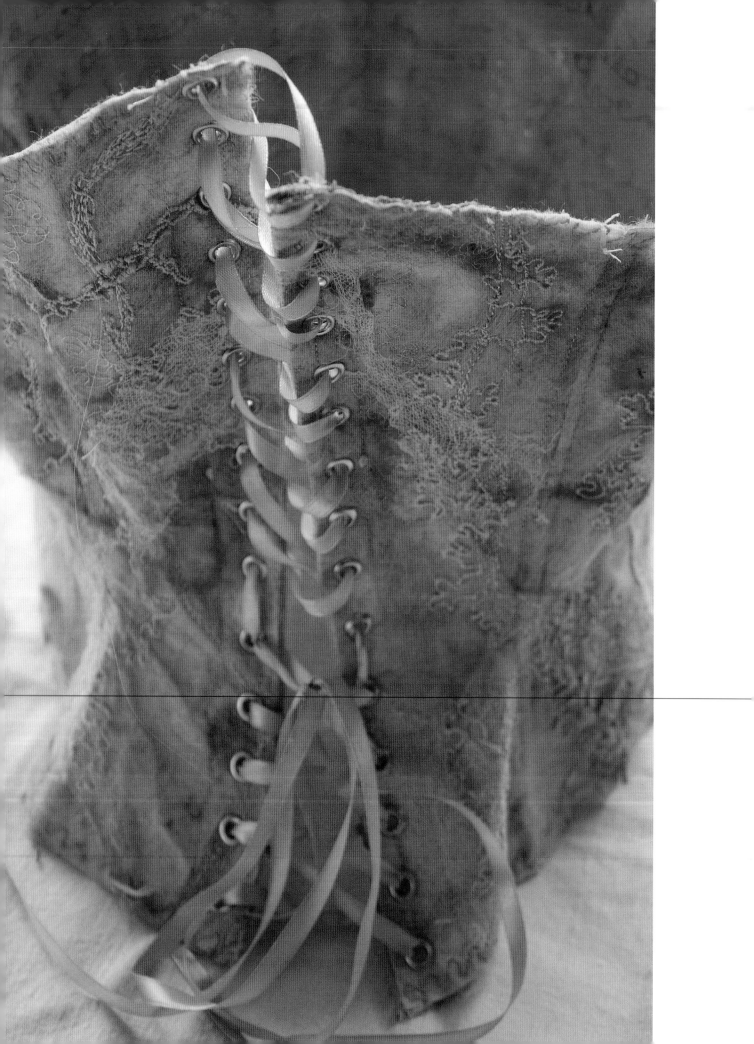

The use of colouring matter

Although fabric coloured with a reasonable amount of acrylic paint can be gently washed, the use of rich pigments and multi-media surfaces may preclude this possibility. An interesting, heavily built up, multi-media surface may simply be too fragile to clean, or too delicate to be worn. Any corset that is to be worn and then washed will require dyeing or colouration that is thorough and lasting.

Sous le Corset il y a un Corps by Marie-Claire Buffeteau

Marie-Claire Buffeteau uses Procion dyes in a lot of her work, so with Procion dye she tried to colour the Lutradur. The dye slipped over the surface and didn't colour it in a uniform way. It was this that made her think of skin. She created the pattern of the corset herself, and in fact it is potentially wearable, although it is not washable. The surface of the corset has a variety of dyed and coloured materials, including wool fibres, felted mulberry paper and lace; these are applied and stitched by hand and machine. The corset is lined with cotton fabric that has also been dyed.

The corset was made after Marie-Claire had produced a series of pots using Lutradur; the final one was based on a corset (shown right).

Left: *Sous le Corset il y a un Corps (There is a Body Underneath the Corset)* by Marie-Claire Buffeteau.

Right: *Pot* by Marie-Claire Buffeteau.

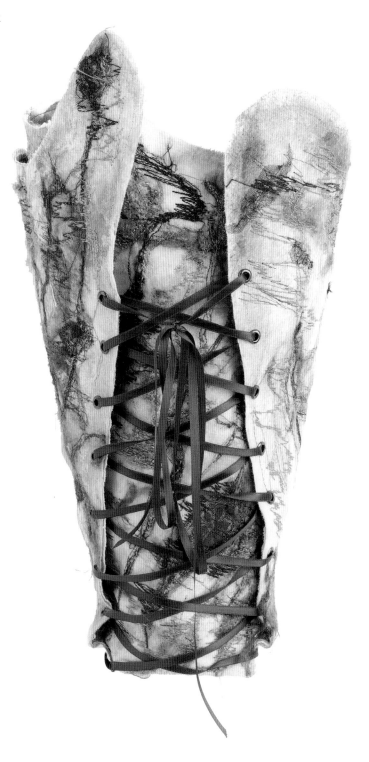

Construction or modelling details

A good example of something that makes a corset difficult to wear is the use of heat-treated materials. When heavily burned with a heat tool, synthetic felts, Lutradur or synthetic organdie can become quite rough and hard. If care is not taken, under the arms for example, such a corset could quickly become quite uncomfortable to wear. When making a wearable corset it is necessary to consider not only how to make the lining against the body comfortable and wearable, but also the outside of the corset where the body will touch it, or a wearable corset could become an unwearable one. A sculptural corset does not have to adhere to these considerations.

There's a telling quote from *The Sylph* by Georgiana Cavendish, Duchess of Devonshire, a novel written as a series of letters in 1778: 'My gentlewoman's gentlewoman broke two laces in endeavouring to draw my new French stays close. You know I am naturally small at bottom but now you might literally span me. You never saw such a doll. Then, they

Encased by Shirlee McGuire. Three mixed-media miniature corsets in a box, hand painted and stitched papier mâché, beading, vintage lace, velvet trim, chains, silk net and photo transfer.

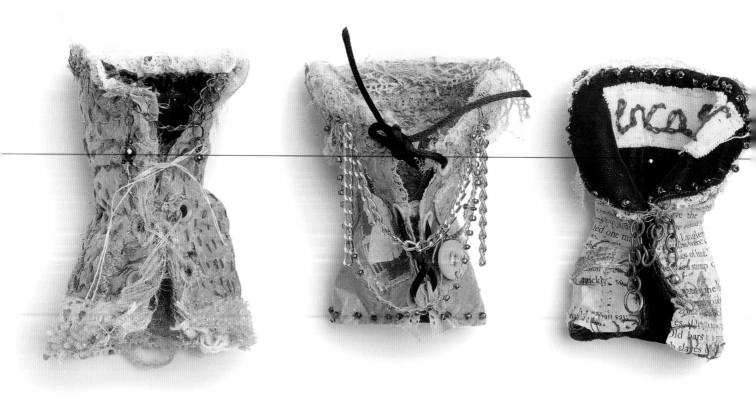

are so intolerably wide across the breast that my arms are absolutely sore with them; and my sides so pinched! – But it is the "ton"; and pride feels no pain. It is with these sentiments the ladies of the present age heal their wounds; to be admired, is a sufficient balsam.'

I love the tone (or should I say 'ton'?) of this quote. But we are less used to dressing uncomfortably these days!

The size of the finished corset

This may seem like an obvious consideration, but the chosen size of a corset may be important for its intended conceptual impact. The availability of the materials, or techniques used may dictate a certain size. Miniature corsets or a collection of the same could allow for a broader look at a set of ideas. Working in oversize for an installation or sculpture may also bring interesting responses, so size is important.

Shirlee McGuire has enjoyed using scraps of paper, lace, chains and stitching to create a collection of miniature corsets (see opposite).

The conceptual element

Inclusions, fabric choices, colouring materials and construction details may have their part to play in deciding whether the corset should be wearable or not, but the overall impact of a conceptual corset presented as a sculptural piece may be more imposing than a garment that is simply worn. The decision will ultimately be that of the maker. The presentation of such a corset will also be important, taking into consideration the representation of the body, and therefore its presence; or the descriptive absence of the body.

Sculptural paper corsets

Paper is a fantastic material for three-dimensional fibre art. Some papers respond well to being sewn together just as a fabric; others can be embroidered with or without a support. Paper can be sculpted when dry or wet or used as papier mâché. Homemade paper can be sculpted around a form and left to dry to become a sculptural object. Paper can be included with textiles to make un-wearable or just-about-wearable art. The possibilities are endless. Much of my own research with corsets and that of my students has centred on paper used in many different ways. There are artists using this medium to make limited-use wearable items too (see page 110, for example).

Paper used in stitched constructions

Some papers respond very well to stitching without too much danger of breaking up if the stitches are big enough, and the holes, therefore, far enough apart. Kraft paper is an excellent example of this, even more so if wetted, manipulated (pleated, screwed up, twisted etc) and left to dry. It can become quite like fabric, and really quite strong, and can then be included in stitched constructions. The paper could be printed, painted, embroidered, coloured, patched, and so on, before being incorporated into a constructed piece. We have had success with a fine hemp paper used in museum conservation, and various other high-quality papers with long fibres can also behave well. Almost any paper can also be stitched – and stitched and stitched – with embroidery until it is the embroidery holding it together and the paper is only the primary support, almost like working heavily on soluble fabrics. The resultant surface could then be incorporated into a sculptural or even wearable piece.

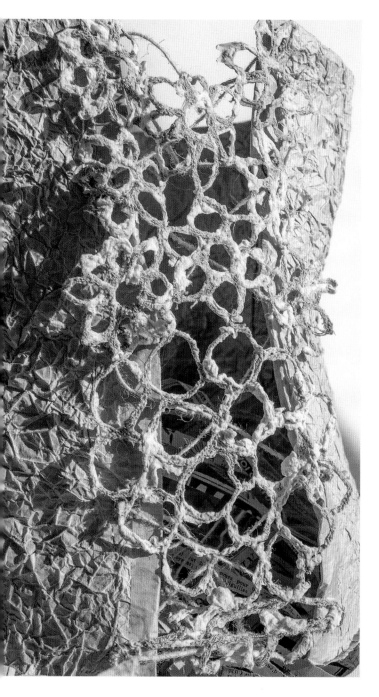

Kraft Paper Corset by
Marie-Thérèse Rondeau.

Kraft Paper Corset by Marie-Thérèse Rondeau

Working with paper of any kind fascinates Marie-Thérèse and she is always experimenting in this medium. A collection of experiments with Kraft paper gradually suggested the idea of a corset. The paper was scrunched up and then stuck to an iron-on interfacing in order to retain the creases. The lace front was made by creating a lace pattern with machine sewing on soluble fabric, which was then dipped into paper pulp. Independently made eyelets are used on the front, and a fringing of old-fashion magazines finishes off the bottom.

Continuing her paper research, Marie-Thérèse made a lightweight corset out of hemp paper (shown overleaf). As a group we had experimented with cigarette paper which is fine and transparent, but tears very easily under the machine, though less so when used double. The 9gsm hemp paper employed here is used in museums for protecting and preserving paper-based artworks by interleaving it between the works. It is very strong but fine and transparent, and dyes beautifully. It also tears along the straight grain in one direction. The corset was made by tearing white and black dyed strips of paper and stitching them on to a base of white hemp paper. Using a corset pattern, the pattern pieces were cut out and assembled. The seams and the top and bottom of the corset were reinforced with plastic boning. The eyelets were made independently (see pages 36–37).

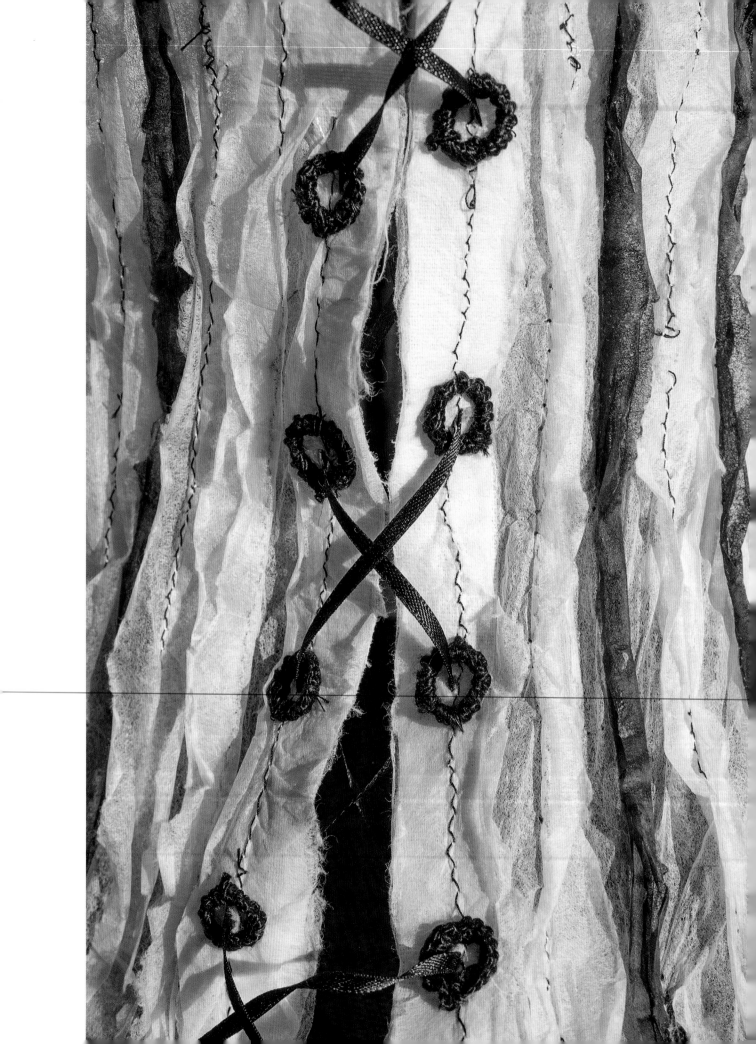

Paper supported with fabric

Paper used as appliqué or transfer on to a textile support could be used for sculptural or semi-portable pieces. Large areas of paper that are not heavily stitched may be too rigid for comfort, but then our ancestors used to have to put up with that too! When stitching heavily on some papers it is often advisable to use a textile support behind them to prevent tearing. This support can be lightweight, but a densely woven or non-woven fabric will be best. Fine silk or cotton could work well without denaturing the handle of the paper. Synthetic organdie could be a useful choice if transparency is required. If it is preferable for the backing to be removed after stitching then 'Thermogauze' is a good choice. This 'soluble' fabric disappears in dry heat using an iron, heat gun or oven. This will cause fewer problems to a heavily stitched paper construction than water-based soluble fabric.

Giving a paper effect to fabrics

Using newsprint or photocopies from surfaces that are obviously paper for lamination or transfer techniques can give a paper look to fabrics and may be a useful solution for a sculptural form or a wearable corset. There are several methods of doing this and they give very different results.

There are quite a few iron-on transfer products on the market that allow you to photocopy or print on to a paper surface that will be used to transfer the print to a fabric surface afterwards by ironing. Some products give hard and even shiny results. Some products give very good fabric quality results. Note that the shine can be taken off the final result by applying a coat of acrylic matt medium.

Fabrics can be bought pre-prepared for receiving a print from a computer printer or the fabric can be soaked in a bath of Bubblejet before being fed through the printer. The fabric should be ironed onto a freezer-paper backing so that it can be easily fed through the printer.

The problem with these techniques is that the fabric printed will be the size of the printer or the print-out and this may not be enough, although the images could be patched together to make a larger piece.

Newsprint and computer print-outs on paper can be easily transferred on to fabric. The technique allows you to work on any size of fabric by simply patching the paper images on to the fabric as you go as explained on the following pages.

Hemp Paper Corset by Marie-Thérèse Rondeau.

Transferring prints on to fabric

This method requires that the images are reversed before using them.

1. Photocopy or print out the images you require as a mirror image onto a fairly rough-quality paper. I prefer unbleached recycled paper for this as it gives an excellent result. Leave the photocopies for at least 48 hours to cure. Newsprint and newspaper give good results and can be used directly if it does not matter if the image is reversed.

2. There are several photo-transfer products on the market but I find that acrylic matt medium gives a very good result. Paint the matt medium on to the photocopy or newspaper, face up, making sure that there is a good, even coat. You will have painted over the image that you require and not the back of it.

3. Place the paper face down on to your chosen fabric and rub firmly with a roller or the back of a spoon. Make sure that there are no air bubbles. Allow to dry. It is best left for 24 hours.

4. Once dry the work must be ironed thoroughly. Allow the work to get quite hot whilst ironing. I find it best to work between two adjacent areas for about five minutes. There will be some vapour, so wear a mask or work by an open door or window.

5. Soak the fabric in water and with a sponge rub the paper away, leaving the print. If you want a distressed image you can use a rough sponge or scourer to create this effect.

Transferring prints on to transparent organdie

The images do not have to be reversed for this method.

1. Prepare photocopies, print-outs or newspaper cuttings. This time the images should be kept the right way round. Anything from the computer printer should be allowed to dry for at least 48 hours.

2. Place the image right side up under the transparent fabric. I find it useful to do this on a piece of glass or Perspex. Paint the medium through the transparent fabric on to the image. Wash the glass or Perspex immediately afterwards and put the fabric out to dry. Then follow steps 4 and 5 as above.

The paper used for the transfer on to synthetic organdie below was a photocopy of a page found in an old school exercise book from the war years. The moral warning about alcohol abuse for girls and women is tough, but insists that abstinence is necessary in order to become a good wife and have a lovely home for husband and children. My intention was to use this on the antique corset but ideas can evolve and the final corset did not include it.

Example from schoolbook ready for use on a corset.

The Merry Widow corset

The Merry Widow corset includes adverts from a 1930s women's newspaper transferred with medium to a black cotton ground. The whole piece was then pin tucked with twin needles in the machine with a cording in place through the back of the pin tucking. Black synthetic organdie was then stitched over the work with free-motion embroidery and burned back with a heat tool. The Merry Widow, *almost* certainly not responsible for her husband's death, has long lost her graceful young woman's stature, but has been waiting for the day when she can happily shop.

The Merry Widow corset by Val Holmes. Pages of publicity from a 1930s magazine on calico with pin-tucking, embroidery and lace.

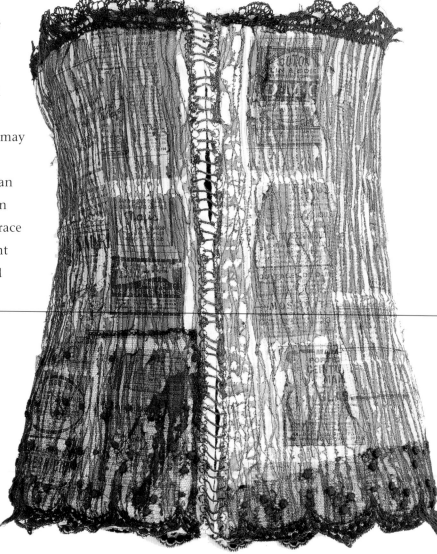

Using cord with twin-needle pin tucking is quite a simple operation. Set up the machine with a twin needle of between 2mm and 4mm spacing. Use the same quality of thread in each needle. If you tighten the needle tensions the effect of pin tucking will be reinforced and special feet exist to make the pin tuck even better. There may be a hole in the plate of the machine under the presser foot where a cord can be passed up through from the bobbin area of the machine (vertical bobbin race machines), if not, a simple attachment for the plate of the machine will hold the cord in place under the work (horizontal bobbin race machines). This cord will automatically be held into place by the bobbin thread when using a twin needle and it will fall into place in the pin tuck, giving a raised, rounded pin tuck.

Paper used as papier mâché

Layering paper as with papier mâché on to a pre-formed frame or tailor's dummy can be a fairly quick build that could be coloured or painted afterwards. Photocopies or photographs could be included, as could textiles or embroidered textile pieces. The paper could be stitched or embroidered before or after inclusion.

Papers can be layered with wallpaper paste or PVA glue on to a preformed frame; chicken wire for example; that will become a permanent part of the piece. If layering paper on to a tailor's dummy, the paper corset will be removed afterwards so cover the dummy first with plastic wrap to allow for easy removal once the sculptural piece is dry and strong enough.

The Bride's Secret Garden, stays circa 1750

The Bride's Secret Garden is worked with tissue paper layered on to a dummy with PVA. Lace was included as the layers were built up, taking advantage of the slightly transparent quality of tissue paper. The central panel on the stays is made on a Lutradur base, with a variety of fabrics punched in with the embellisher machine, and then embroidered with free-motion machine embroidery.

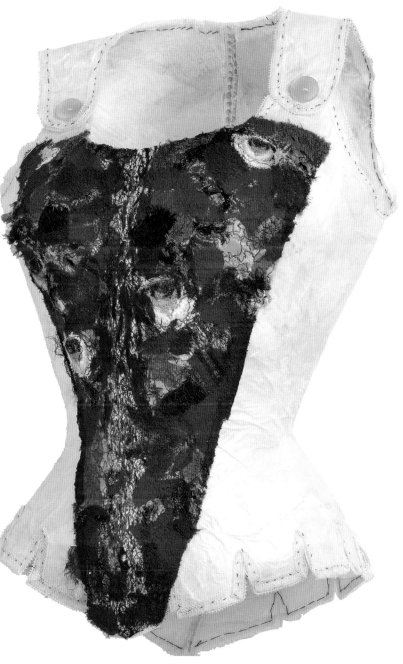

The Bride's Secret Garden by Val Holmes. Stays in the style of the 1750s, made from papier mâché and a panel of embellished and embroidered Lutradur.

Homemade paper

I use the term homemade paper deliberately, as hand-made paper could imply bought hand-made paper. Moulding with homemade paper requires a little dexterity, but it's a technique that is fairly easily acquired. Each piece of formed homemade paper is taken off the forming frame on to a kitchen cloth, felt or synthetic organdie; it can then be easily handled and placed directly on to the mould. If the mould is a tailor's dummy, it should be covered in plastic wrap for easy removal once dry. Layers of paper can thus be built up to create a sculptured form. The paper can be fine, or thick, have inclusions or not, and could even be formed over lace or fine thread. If necessary the paper could be consolidated afterwards with acrylic wax or PVA medium.

Autumn Snow corset

This corset dress was inspired by seeing snow on trees that were still covered with rust-coloured leaves. A very large loose lace fabric was stitched on to dissolvable fabric on the sewing machine with rusty orange thread. The dissolvable fabric was washed away and the resultant lace was then dipped into a vat of paper pulp, pulled out and left to dry. It was then used as a fabric to create the laced-up corset dress.

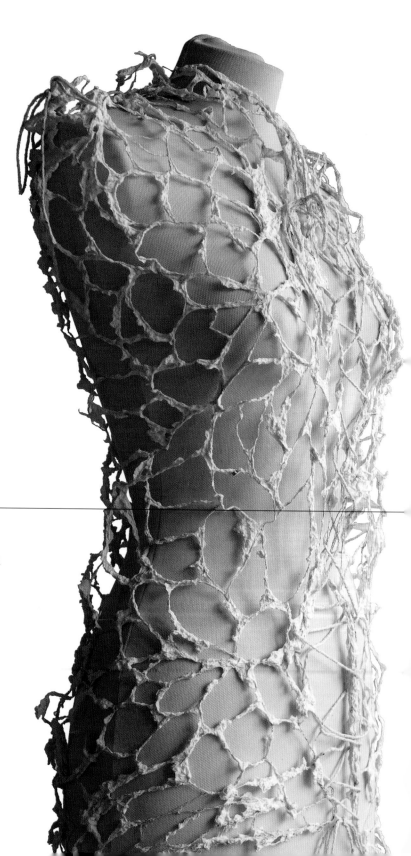

Autumn Snow corset dress
by Val Holmes.

Mulberry-fibre miniature corsets

I was tempted to make a moulded corset using mulberry fibre, but a full-size corset was impossible simply because the mulberry fibres that I had acquired were very short and quite fragile. Rather than give up on the idea I purchased a small mannequin and used the fibres mixed with homemade mulberry-fibre paper to make a series of miniature corsets.

The homemade mulberry-fibre paper was created from the fibres that were too fragile to be used independently. These fragile fibres were mixed with a large quantity of water in a blender and poured over a forming frame. I used a screen-printing frame to create the smooth quality of the paper surface.

The miniature mannequin was covered with plastic wrap, and wet mulberry fibres gently stretched over it. The paper formed out of the leftovers was released on to a piece of synthetic organdie and then modelled on the mannequin where the fibres were already in place. Some extra fibres were added here and there, then the piece was allowed to dry.

On the small scale the paper and mulberry fibre stand up well and hold their shape. Using different colours to lace the corsets, and some stitching here and there, the corsets form a series.

Mulberry-paper corsets by Val Holmes. From left to right, *Lavender Days*, *Femininity* and *Hurt*.

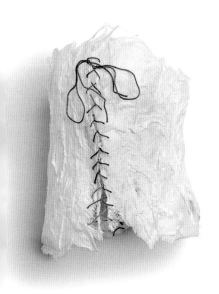 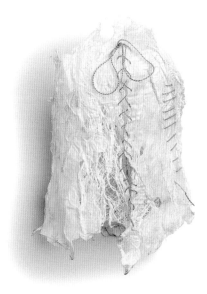 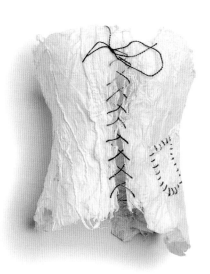

33

Cocoon strippings

It is possible to sculpt gummy silk paper made from cocoon strippings around a form with an iron. To turn the cotton-wool-like cocoon strippings into paper this is what you do.

1. Gently tease out the silk fibres on to baking parchment until the desired thickness is reached. Note that the fibres can be quite thinly spread and yet still make a firm paper.

2. Make the fibres quite damp or even wet by spraying water on to them. Place another layer of baking parchment over the fibres.

3. Iron with a hot iron until completely dry. The paper should be firm. If any areas remain a bit woolly it is because the fibres were not fully wet before the ironing began, or because the ironing process was not continued until they were completely dry. In any case the process can be repeated with the same fibres for a better result.

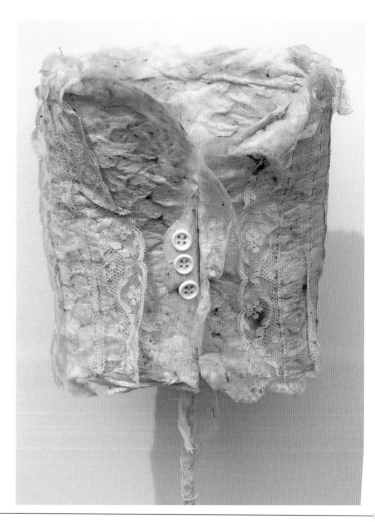

It is possible to sculpt the cocoon strippings over a form protected with baking parchment, and then protect either the work or the iron with baking parchment in order to iron the fibres until dry. For a large piece to retain its shape the fibres will need to be quite dense. All sorts of oddments can be included when layering the cocoon strippings together: flowers, paper, lace or embroidered bits: enjoy experimenting!

Small Corset by Val Holmes. Chicken wire was placed between a sandwich of gummy silk and then ironed. Lace and buttons were added by hand. The corset was formed with the help of the chicken wire.

Mrs Beeton's Maid

Mrs Beeton's *The Book of Household Management* was first published between 1859 and 1861 in monthly supplements in *The Englishwoman's Domestic Magazine*, which was owned by Mrs Beeton's husband. The supplements were printed as one volume in 1861. The frontispiece carries a quote from Milton: 'Nothing lovelier can be found in Woman, than to study household good.' The book covers everything from bringing up children to cleaning every possible household article, how to cook, how to budget, and how many servants you may be able to afford according to your income. This was the book that told our mothers and grandmothers how to cook Christmas cakes and roast beef.

The corset for Mrs Beeton's maid is made using pieces of fine gummy silk paper with lace inclusions as well as torn, machine embroidered paper from a facsimile of Mrs Beeton's book. The pages chosen dictate the services expected from the maid of the household. Finer silk papers with inclusions may need an additional support other than just glue in order to keep their form. *Mrs Beeton's Maid* is stitched by hand onto a chicken-wire support. The chicken wire is painted but still visible and may remind us of all those hypocorisms for women that turn around poultry: old duck, mother hen, chick and so on.

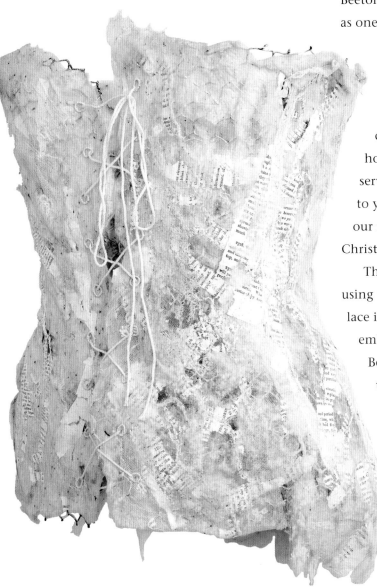

Mrs Beeton's Maid by Val Holmes.

Eyelets

Eyelets as fastenings are particularly important to give a piece that authentic corset look. Metal eyelets may well hold on to some paper surfaces, but they could be inappropriate to its look and feel. Hand- or machine-stitched eyelets with the density of stitching required could really undermine the strength of the paper. One solution is independently made eyelets that can then be sewn into place on to the corset's surface. These eyelets do not actually surround a hole on the corset itself, they are just for show. The ribbon or cord lacing the corset together will pass through the paper corset and through the middle of the false eyelet without putting too much undue strain on the corset itself. These eyelets can be added to any fragile garment once made, and could be useful on lace corsets as well as paper ones. They can also be added to surfaces that are too hard or difficult for hand, machine or metal eyelets. The working method is as follows:

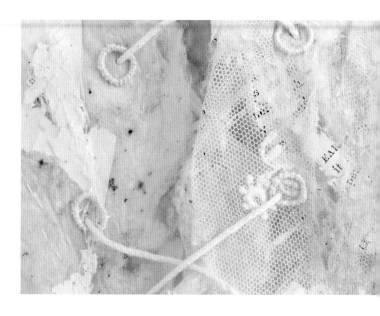

Detail of eyelets from *Mrs Beeton's Maid* by Val Holmes.

1. Thread a needle with thread such as cotton perle or a silk thread with a twist. Wrap the thread three to five times around the top of a pencil, holding the thread end.

2. Holding the wrapped threads firmly, push the needle underneath them.

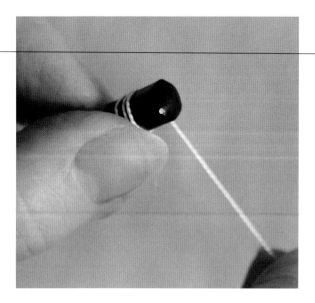

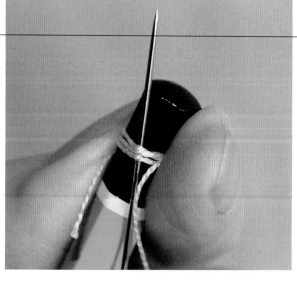

3. Buttonhole stitch the wrapped threads together. To do this the thread is taken in front of the needle and then passed behind it.

4. Note that a buttonhole stitch gives a little knot when drawn tight, unlike blanket stitch which does not. This difference is essential.

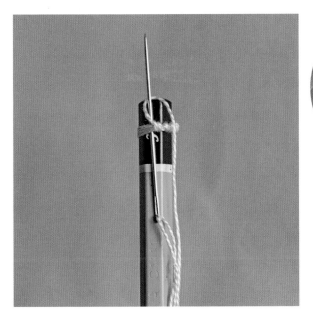

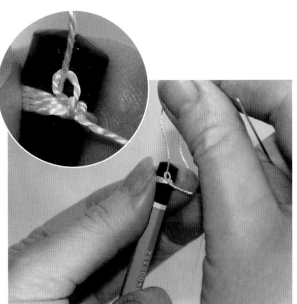

5. Work buttonhole stitch around the wrapped threads until you are back where you began.

6. Once finished the buttonhole-stitch eyelet can be removed from the pencil. The remaining thread still attached to the eyelet can be used to sew it into place on the corset with just a couple of stitches.

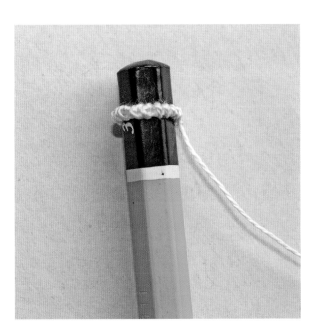

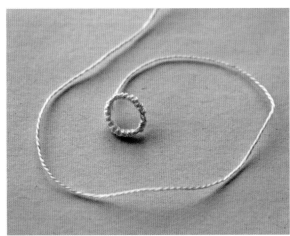

Silk fibre and fibre papers

Silk paper made with silk fibres and wallpaper paste or PVA glue moulded on a frame such as a tailor's dummy will retain its shape extremely well, especially if a thick paste is used. Other animal fibres, wool, or even natural threads can be used to make a firm structure with this technique. The dummy must first be protected with plastic wrap to ensure easy removal once the work is dry. Again all sorts of inclusions are possible in the paper.

To make such a cloth this is what you need to do:

1. Put a sheet of firm plastic on the table, followed by a piece of net or synthetic organdie a bit larger than the desired size.

2. Spread out the fibres on to the net. Make sure that there is some interweaving or criss-crossing of fibres. The crossing of fibres doesn't have to be at right-angles, but should be at least forty-five degrees.

3. Other objects may be included at this point such as threads, feathers, dried flowers and so on.

4. A final fine layer of fibres will be required at a different angle again to hold in place any inclusions.

5. Place another piece of net or organdie over the whole piece. Using a paintbrush or your hand, rub your chosen glue into and through the fibres. This can be thin or thick wallpaper paste, slightly diluted or heavily diluted PVA glue (1 part PVA to 1 part water up to 1 part PVA to 5 parts water), acrylic medium or, if using silk fibres, you may wish to use silk-paper paste for a more natural finish.

6. If you have used thick pastes or glues the resulting 'paper' will dry stiff and so can be moulded at this point. Carefully remove the net or organdie from one side of the paper; this should be the side which will be on the inside of the corset, and the choice is important if you have made inclusions as you will want these to be visible from the outside. Using a tailor's dummy covered with plastic wrap, or moulded chicken wire, take the paper and mould it over the form with the wrong side facing the form. The net or organdie on the right side of the paper can be more easily removed when the paper is almost dry.

Detail of *Mrs Beeton's Maid* by Val Holmes.

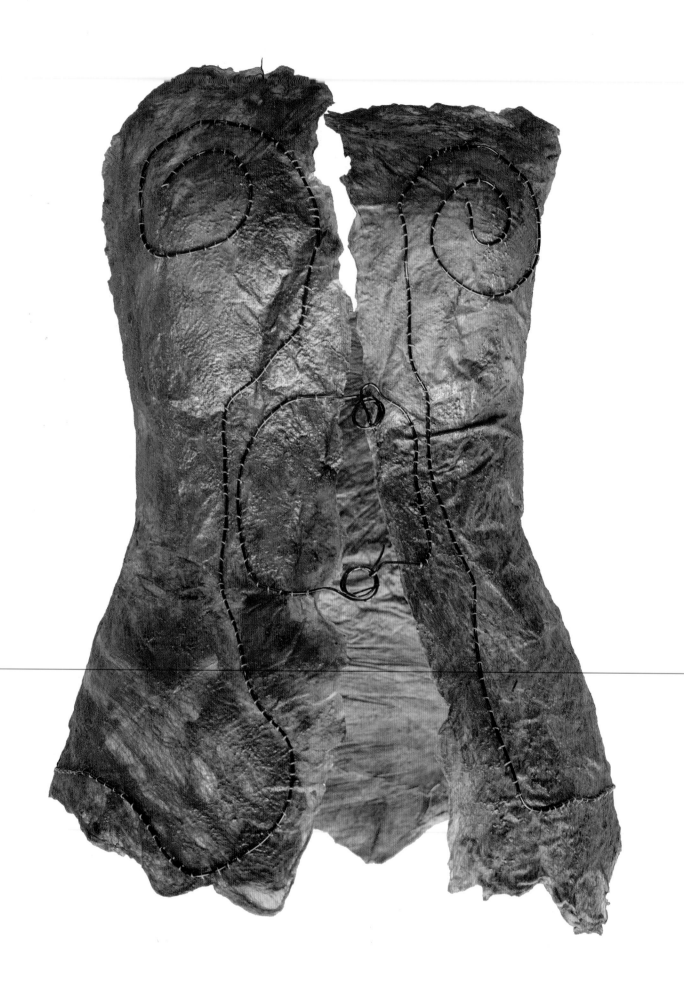

Finishing off

If required, paper pieces can be protected with PVA glue which will give a shiny result, acrylic wax which will give a waxy lustre, or acrylic matt medium which will give a matt finish. Although such products will denature silk-fibre paper, they can be fine on ordinary cellulose-based papers. A piece that has been constructed with PVA can be painted afterwards with acrylic matt medium to take off the shine. For additional solidity, textile hardeners can be used; some hardeners can be purchased with waterproofing compounds.

This Golden Earth: Corset for Gaia

The starting point for this corset was the idea of a skin 'moulted' corset shed from Gaia as the earth goddess tries to cleanse herself. But as the idea evolved I decided it would be more pertinent to celebrate the earth's skin and make it into something precious rather than something cast off.

The fibre base was worked with an embellisher machine on soluble fabric. This is a method that quite successfully makes felt with wool fibres, or silk 'felt' with silk fibres. The fibres were punched into the soluble fabric with the embellisher machine until the back of the work resembled the front; at this point the fibres could hold together on their own once the fabric was removed. The soluble fabric was removed with cold water, leaving a good amount of residue in the fibres to hold a sculpted form. The fibres were then sculpted over a tailor's dummy that had been covered with plastic wrap.

Once formed and dry the corset was painted with acrylic wax for more firmness and gold metallic powder was added to the final layer of acrylic wax. In between each layer the wax was allowed to dry.

Stitching and wiring were added to decorate the corset whilst at the same time increasing its stability. Hand stitching was used to hold the wire in place as a heavy machine line would have broken the fibre paper.

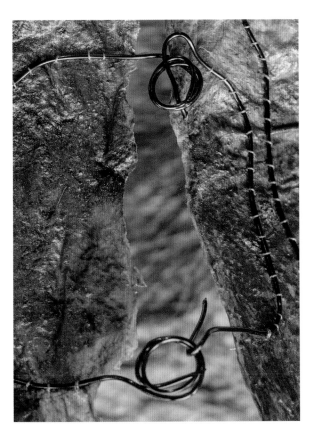

This Golden Earth: Corset for Gaia (shown left) with detail of closure (shown below), by Val Holmes.

Metal sculptural corsets

My first sculptural metal corset appeared in *Creative Recycling in Embroidery* (Batsford, 2005). It was worked in a crazy patchwork with cut pieces from colourful soft drinks cans sewn on to soluble fabric, edged with barcodes and closed with colourful electrical wire through ring-pull eyelets. *Full Metal Bodice* was conceived for a woman who sold her body (hence the barcodes) with a protective carapace that could be as easily opened as a ring-pull can.

Many metals can be stitched and sewn by machine quite easily. The major problem is thread breakage, because the needle entering the metal can create a burr on the underside that will wear or cut the thread when the needle lifts. A soft fabric backing will absorb this burr and prevent thread breakage; if the work would be better without a fabric backing a soluble fabric, preferably a non-woven type such as Solusheet, can be used to absorb the metal burr on the underside of the metal, and yet be dissolved after stitching.

Full Metal Bodice by Val Holmes.

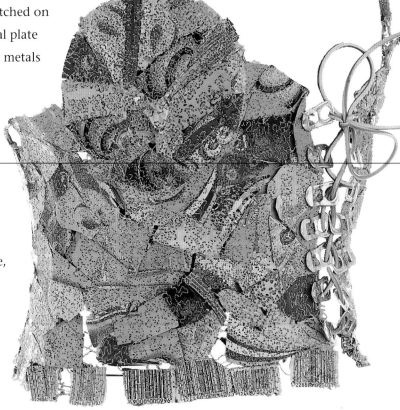

Metal plate such as aluminium drinks cans and tomato-paste tubes can be stitched on with a sewing machine. Fine metal plate can also be purchased in different metals and finishes. Fine metal fabrics in copper, steel and other metals also exist and can be used for garment creation. The finer the metal is, the more you may feel inclined to create a wearable corset.

The very nature of metal, suggesting an armour or carapace, can already help the conceptual element of the corset. Some early examples of corsets exist from the 15th and 16th centuries constructed completely in metal, but

these are largely thought to be corrective pieces for deformed spines. In any case, metal, as well as cane and whalebone, was used in historical corset construction to confine and reshape the body, which makes the use of metal in the fabrication of a sculptural corset particularly pertinent. The use of metal can thus inspire a notion of cruel caging, reforming and enforced remodelling, underneath the protective, defensive exterior. References to the use of chastity belts may also be inspired by sculptural metal corsets and underwear.

The miniature metal corset below is much more lightweight in concept and has more to do with gardens than dungeons. Fine green chicken wire salvaged from a floral bouquet was woven into by hand and stitched over by machine to form a surface solid in some areas and lacy in others.

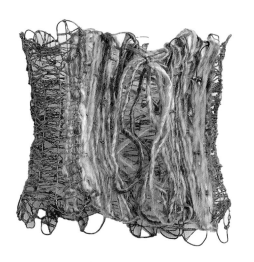

Miniature metal corset by Val Holmes.

Metal wire

Working from the idea that boning in modern corsets is often based on wire, wire may actually be used to construct the corset by stitching wire onto fabric, or creating a lace with a wire structure on dissolvable fabric. Metal wires of different thicknesses and colours can be purchased, or you could use electrical or garden wire with plastic coatings, available in different colours. Cotton-coated copper wire, available in different thicknesses, also forms a good base, and can be dyed to suit your colour needs. See page 102 for work by Diane Bates constructed on a coloured wire base.

Tree barks, leaves and grasses

Some tree barks and leaves can lend themselves to stitching, particularly if treated first with acrylic wax which will make them supple and easier to stitch without cracking and breaking. Thus treated they can be stitched together to form a three-dimensional corset either by hand or machine. A base fabric could be used to make such a piece more stable, but the ephemeral quality of the piece may be more suitably left without support. Weaving grasses, twigs, willow and so on, with or without textile inclusions, may also be an interesting option.

Bark and *Abacá* corsets by Claudia Boucard

Claudia wished to produce a series of corsets out of improbable and fragile materials with the idea that the use of such materials softened the notion of torture that a corset can suggest. Working these two corsets, Claudia fixed two challenges. The first was to work with the complexity of the corset as a pattern and construction, and the second, to use difficult and unsuitable materials. She tested the textures of natural fibres from birch bark and abacá fibres. In order to embroider these materials as if they were actually textiles, she painted them with acrylic wax, then placed them between a sandwich of soluble fabric. These elements were then stitched together to create a piece of cloth.

Claudia made a pattern and cut it out of the resultant 'cloth' and assembled the parts of the corset. She adapted the stitching and embroidery according to the fragility of the materials. The boning is interpreted with sticks of hazelnut tree for the bark corset, and with bamboo for the abacá corset.

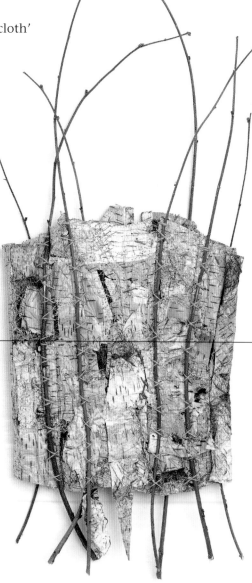

Bark corset by
Claudia Boucard.

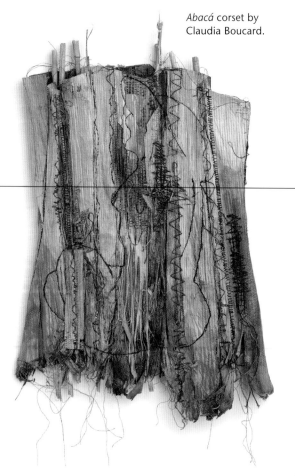

Abacá corset by
Claudia Boucard.

Plastic

Plastic can be burned, layered, moulded, stitched and used as an opaque or transparent material. If used as a transparent material, inclusions can be placed between two layers of plastic and stitched or heated into place.

Plastic gently heated with a heat gun can be persuaded to shrink to the shape of a form. See page 63 on wearable plastic. If heavily heated, holes will form and different plastics will meld together.

Safety tip: when working in such a way with plastic wear a good-quality mask, if possible work outside or by an open door or window, and always have a bucket of water handy just in case.

When stitching on plastic under the sewing machine any good-quality needle will do. Heavier plastics or PVC may require a denim needle. If the plastic you have chosen is very thick, holes can be made with a soldering iron for hand stitching. Remember to wear a mask when using a soldering iron or any heat tool.

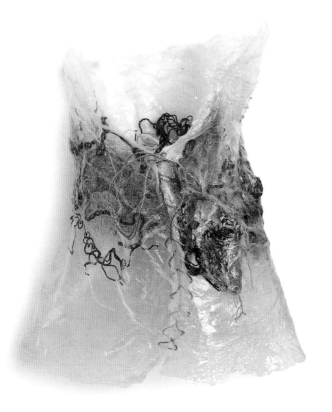

Miniature plastic corset

Various bits of waste cotton and silk were placed between several layers of plastic wrap and gently ironed between baking parchment so that the layers melded together ever so slightly. A miniature mannequin form was covered with aluminium foil. The plastic was wrapped loosely around the form and very gently heated with a heat gun, which caused it to shrink around the form. The work was cut along the front edge and sewn together with lacing in a corset style.

The Mermaid's Corset by Val Holmes. Plastic corset miniature made with studio floor sweepings trapped between kitchen plastic. With too much plastic and rubbish in the sea, the mermaid's chosen fabric is inevitable.

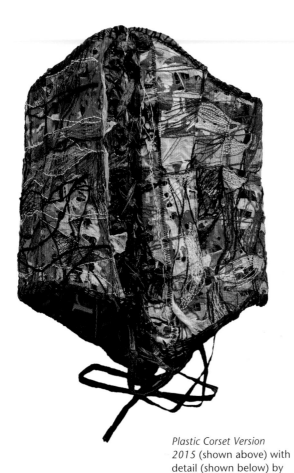

Plastic Corset Version 2015

This corset by Claudia Boucard was constructed according to a pattern from 1890 with plastic from shopping bags. Bands of plastic were first woven together to produce the panels. These were stitched to hold the weaving in place. The plastic was then heated with a heat gun. During this process it acquired holes as it shrank and fixed itself to the stitching. The colours changed as the plastic deformed and holed, allowing the different layers of plastic to show through. As the plastic fuses the attempt to control the fusion can become quite exciting according to Claudia. Once melted and cooled down the plastic becomes stiff and hard, like a form of armour. Thus the romantic 1890s corset becomes a useful protection.

Plastic Corset Version 2015 (shown above) with detail (shown below) by Claudia Boucard.

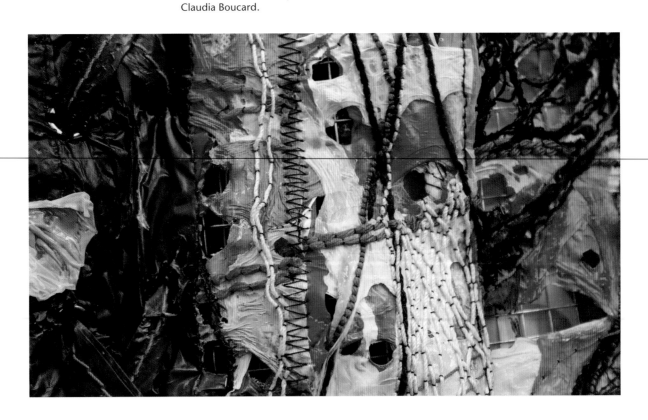

Resin-printed 3D corset

Printing in 3D offers further dimensions (literally) for the artist. These small corsets were created by Lucy Vallin. She modelled the corset on a 3D computer program used for generating animated images. But free programs such as SketchUp could have done the job. The corsets were then printed on a 3D printer before being sewn in the holes that had been left for that purpose.

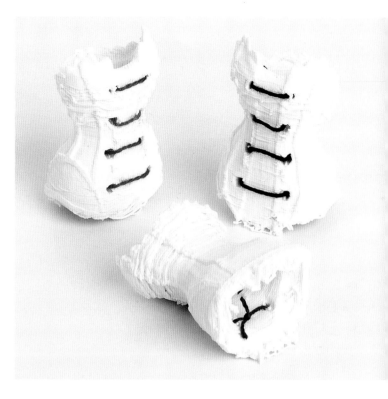

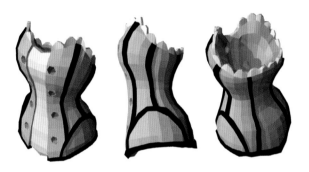

Left: Three images of 3D corset for 3D printing.

Above: Resin corsets by Lucy Vallin.

Fastenings

The way in which a corset is laced up or otherwise closed can say so much about the corset and the wearer. Reappropriating everyday items effectively as fastenings can also be a way of making a statement. Keys, spoons, screws or nails, hair clips, rollers, paper clips or staples could all offer a different way of holding garment pieces together, each implying something different for the potential wearer.

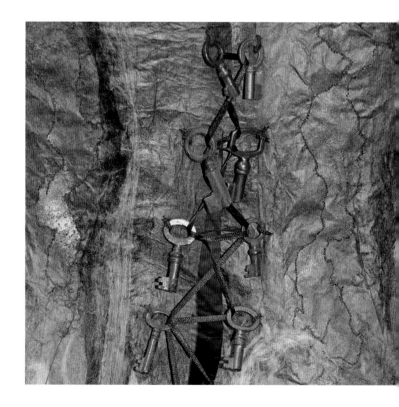

The Woman of the Keys by Martine Amans.

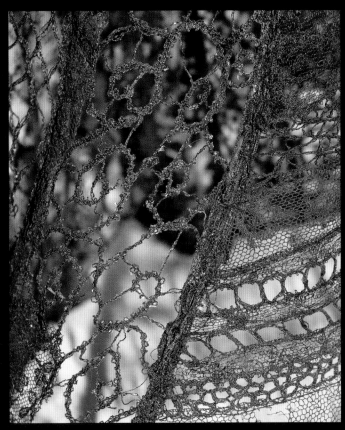

The *Black Widow* corset combines old lace and machine-made lace.

Truly Wearable Pieces

The tenet of this book is not to explain in detail the many approaches and techniques necessary for the making of different types of contemporary or historical corsets. There are many books and websites that show these techniques in enough detail to help the average sewer with a good pattern to achieve simple to moderately complicated corsets. I have, however, included build-ups of a simple pair of 'jumps' and a fairly simple corset, with explanations of where I altered the pattern and construction details for simplicity, bearing in mind that the corsets are art corsets and not really made for a great deal of wear. Ideas for further reading and useful websites are given at the end of the book.

In this chapter we will look at how these techniques, simple and more complicated, can be used to create wearable corsets that are nevertheless rooted more in the notion of their concept than in their functionality.

Wearable corsets in fabric

This very simple bodice design is a good place to start for the novice sewer. I took the pattern and the idea of a pair of 'jumps' and adapted it as described below. Jumps were a less-fitted, usually boneless garment, often used in the 18th century by aristocratic women for casual or county dress.

A pair of jumps for Marie Antoinette

Marie Antoinette's idealized vision of village life around her small beloved chateau in the grounds of Versailles is just the sort of place to wear a pair of jumps. One portrait of her by Elisabeth Vigee-Lebrun shows her wearing an English smock shirt in a country style, so the idea of back to nature was very present. This image was frowned upon at the time and thought of as tantamount to treason, but then most of what Marie Antoinette did was frowned upon anyway.

Another portrait of Marie Antoinette in more elaborate dress by Vigee-Lebrun shows her with metallic laces and beautiful metal tassels, and I have used these as an influence for the lace on the jumps.

The fabrics used in the piece are examples from a catalogue of *Toile de Jouy* or copies of the famous *Toile de Jouy* pattern. This famous 'indienne' or chintz comes from Jouy en Josas, close to Versailles, where a manufacturer of this type of fabric set up in 1760. Colours were simple; usually only one colour was printed on a cream or beige background. The colour was more often than not red. This type of printing on linen or cotton was at first done with wood blocks, but later developments with etching improved the technique, and from 1770 an etched copper cylinder was used to print dense and detailed fine prints of pastoral scenes. This is the perfect fabric for Marie Antoinette's jumps, so close at hand, and more apparently patriotic than an English smock, even if the factory was started by a German (later naturalized as a Frenchman) and the copper etching process was invented by an Englishman!

But Marie Antoinette's history catches up with her and the stitching that I used to quilt the jumps, which is used to emulate the kind of cording found on more supple corsets, is inevitably red after her passage under the guillotine.

Marie Antoinette's Jumps by Val Holmes. The jumps incorporate nature and countryside imagery, particularly in the *Toile de Jouy* pattern, which was manufactured close to her beloved chateau in Versailles. The red and gold stitching, with 'drops of blood' and 'drops of gold' motifs, hint at her lavish but ultimately bloody story.

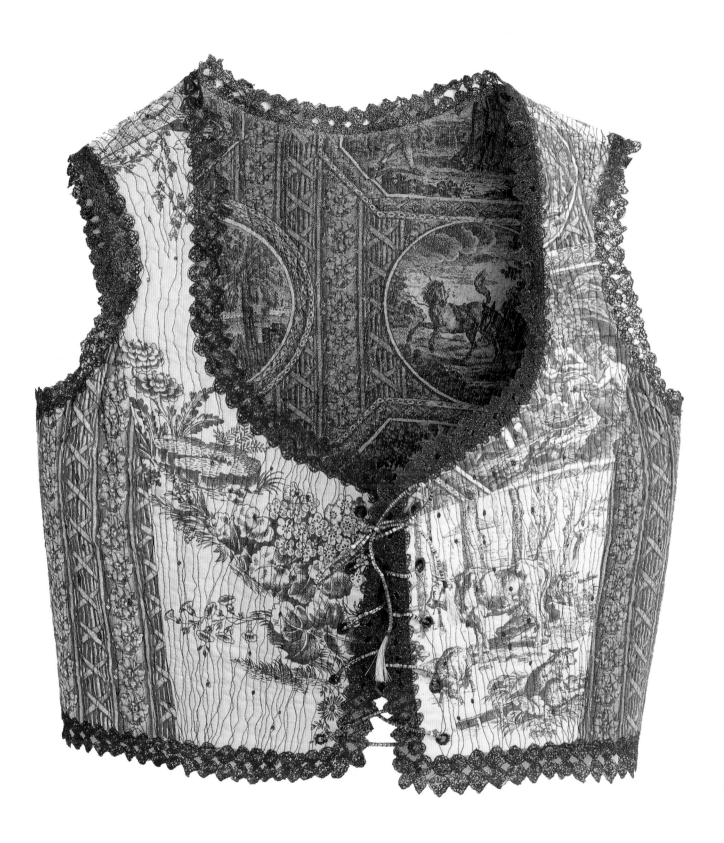

Making the jumps

The jumps were made using Butterick's B4669 pattern A. This is a very simple bodice pattern and a good start for a beginner. The main fabric and lining were cut from fabric samples from a fabric sample book, and a thin wadding was used to make the jumps sturdier and allow for light quilting. To make such a cloth this is what you need to do:

1. This pattern is very simple and requires only five pieces that fit easily together. First the lining pieces were stitched together.

2. The main fabric with the quilting fabric included was then stitched together and the wadding cut away from the seam allowances.

3. The lining was joined to the main body of the jumps right side to right side along the outside edges, with a small area unsewn along the bottom to allow for the jumps to be turned right side out.

4. The remaining edges were turned in and a band of soluble fabric was attached with soluble thread around the edges of the whole garment.

5. The eyelets were machine stitched with layers of machine running stitch, cut, then reinforced with satin stitching around the eyelet.

6. The lace edging was stitched with a red thread in the needle and a gold thread in the bobbin of the machine and this was worked directly on to the soluble fabric to create lace and also on to the body of the garment to hold it simultaneously into place.

7. When designing the work I had decided that I would add red beads by hand at the end as 'drops of blood', but as the work progressed I realized that the jumps were in fact reversible with a gold-rich side and the red (bloody) side. So I made 'drops of blood' with the red thread in the needle or 'drops of gold' with the gold thread on the bobbin with small rounds of heavy machine stitching here and there so that the jumps remained reversible.

8. A gold skein of thread was wrapped with an open zigzag stitch on the machine for the cord to close the jumps.

Nana's Corset in blue

At a time when decent upright women wore white corsets, and buff or khaki could be acceptable for working-class woman, other colours made quite bold statements. Although dark blue and red corsets have come into collections, and are usually in good condition, it is always worth noting that the corsets that survive are usually those that were little worn. Perhaps these more unusual and striking colours were for balls and special occasions.

Édouard Manet suggested that 'The satin corset may be the nude of our era' when he painted Nana wearing a pale blue corset in 1877. The painting of a 'fille de joie' putting on her make-up with the half figure of a dressed man also in the painting created a scandal; much as his *Le Déjeuner sur l'herbe* had done in 1863 by presenting dressed men with naked women in a contemporary setting. Nana was the victim of poems, scandalized texts and cartoons. It was refused from the 1877 salon, but did find supporters who admired some of its skills, and most particularly pointed out the relationships presented in the picture – that of a courtesan and her client. We are aware that this client is not there for the first time, and we are also aware, by the surroundings in Nana's room and by the choice of her stockings and shoes, as well as the silk corset, that this is a girl from a poor background who is now able to pay for the luxuries she dreamed of. The pale-coloured silk corset is fleshy and voluptuous, and promises much for the young woman who is wearing it. The title

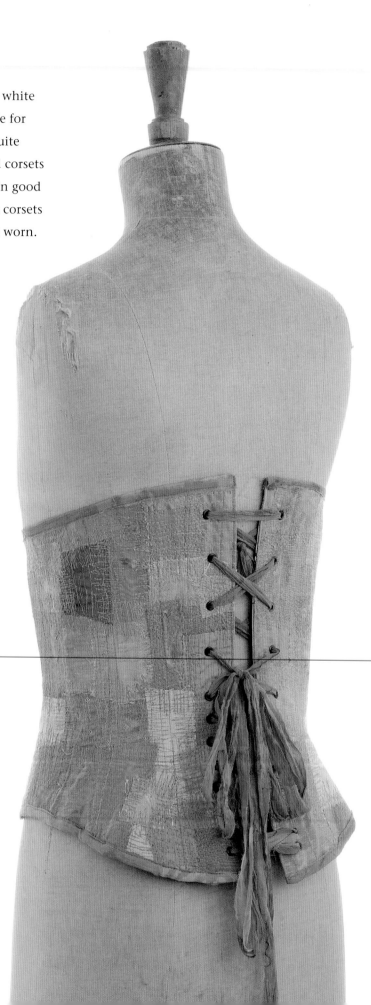

of the painting refers to a character in a book by Zola about the life of a courtesan of few morals published two years after the painting, but Manet probably gave the title to the painting once he had learnt of Zola's new book to be published in the book series 'les Rougon-Macquart' on working life.

Corsets appear in many paintings of the time, particularly by the Impressionists, and more or less laced up. The corset came to represent the nude; clothed nudity raises controversy as it invites sexuality into the tableau. Although drapes in antiquity are used to hide the parts of a nude figure that it was considered indecent to expose, clothing – particularly undergarments – implies the act of dressing or undressing and therefore of a potential sexual act. The controversy is evident in a world full of Victorian prudery, where even the words to describe undergarments were considered unclean, let alone the garments themselves.

For Nana a beautiful blue satin corset at the height of her career was a must, but as time goes on I imagine it as being repaired and patched, a symbol of past glory and future decay.

For this corset I used the Butterick pattern number B4254 pattern C. For a first real corset this pattern is quite simple to use as it only has 12 pattern pieces. The instructions with the pattern are excellent and easy to follow. Working with machine-stitched appliquéd fabrics allowed me to use machine stitching to apply the boning and reinforce the seams and edges as this stitching is lost in the heavy appliqué stitching. Binding the top and bottom edges also made the corset manufacture easier.

Nana's Corset by Val Holmes (shown left). Made from patches of satin cut from fabric catalogues, the machine stitching is reminiscent of darning as Nana's once-beautiful corset reflects her fall from grace. The inside of *Nana's Corset* (shown below) is made from *Toile de Jouy* and similar fabrics that depict cupids and voluptuous women.

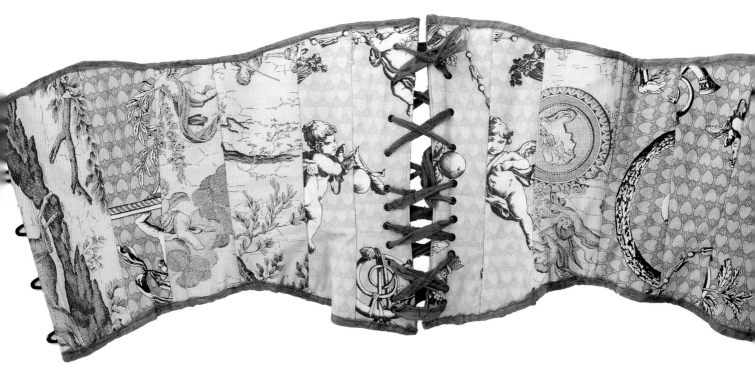

These changes to the corset construction will make it simpler for the beginner, although it does require the ability to sew accurate lines with the machine. I made the following adjustments to the pattern construction:

1. The pattern was cut out of heavyweight calico, I didn't make any pattern markings at this stage as I knew that they would be lost in the making. The sides were sewn together as per instructions (6 pieces each side), and the seams ironed open.

2. Small pieces of pale-blue satin, brocade and satin twill were appliquéd on to the surface using free-motion embroidery to create the look of darned patches. The movement and curve of the pattern pieces and the grain of the applied fabrics were taken into consideration so that the 'fall' of the corset would not be compromised.

3. I used plastic boning, instead of metal. This can be stitched into place by machine, so it was added this at this stage along the placement lines before continuing the corset. Plastic boning offers a simpler solution for the beginner and is more supple for the wearer if the corset is for decoration and not 'slimming' purposes.

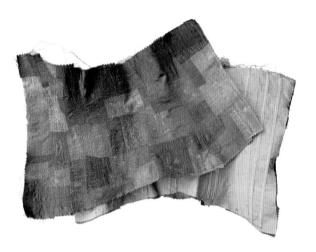

4. The lining was cut out of *Toile de Jouy* upcycled from furnishing-fabric sample books. I found several fabrics with cupids on, which seemed appropriate for Nana.

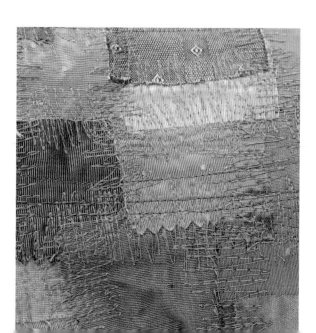

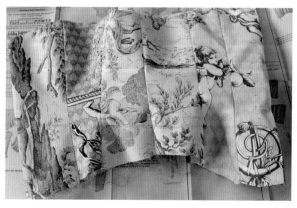

5. I decided it would be easier, and more in keeping with the concept of the corset, if it was made with bound edges top and bottom, rather than made with the lining back to back and turned inside out as per the instructions. So I carefully placed the busks into position, drew the necessary lines, and stitched the lining and corset panels together just along the front and back edges, leaving the holes for the busk panel front right as necessary.

6. For the buttons on the other busk panel, I drew their placement carefully, but instead of using glue or fray stopper, I stitched around the future hole with several rows of free-motion stitching. I then made the hole for each of the buttons on the busk to pop through.

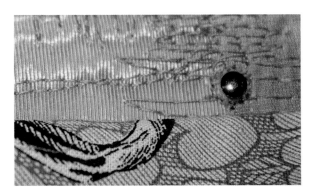

7. Once this was achieved I turned the corset right side out and, stitching from the lining side, stitched through both layers along the seams, along the edges, and just against the busks to hold them in place.

8. The top and bottom edges were bound with cut sari silk as I had some colours that I found appropriate, but any sort of binding could have been used.

9. Holes were made and eyelets added with an eyelet tool (see Suppliers, page 126) as per instructions. The eyelets could also be made by hand or machine.

10. The corset was laced with the same sari silk as was used for the binding. It's obvious that this silk is really too fragile for this purpose, but if the corset is not laced up strongly it holds.

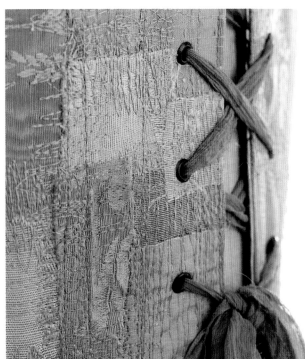

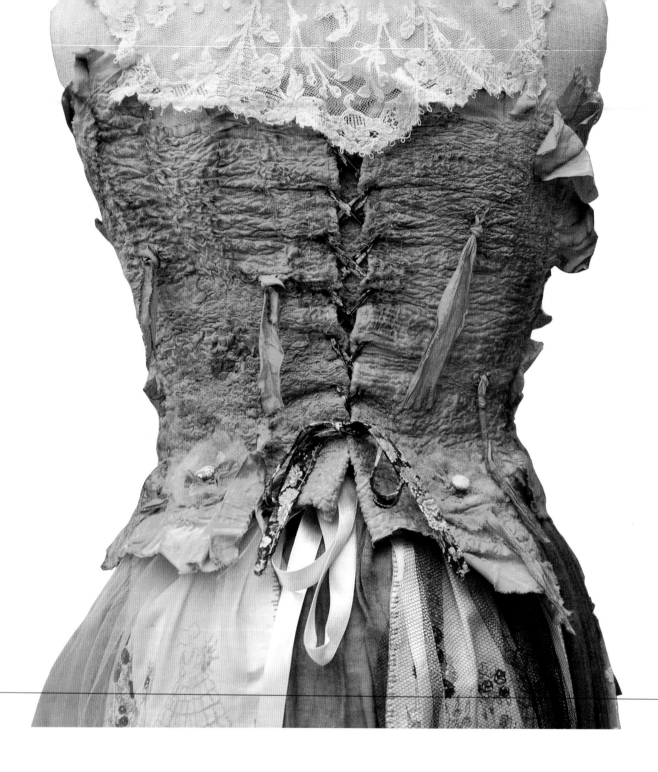

Priscilla by Helen Marchant

Her love of textiles encouraged Helen Marchant to put together pieces she had
collected over the years – buttons, ribbons and other scraps – with her own
pieces of work. The bodice was constructed with odd bits of natural scraps, free
machined on to a wool gauze, washed and Procion dyed. The skirt was created
with pieces of recycled embroidery panels, old embroidery transfer tablecloth,
lace, dyed gauze and net. The dress could be worn if wished.

Wearable corsets in lace

Working with transparency is obviously more difficult than working with fabrics and linings that can be reinforced. A lace corset will therefore have to fit exactly and, because of the delicacy of the materials, will probably not be suitable for tight lacing.

It is best to choose a corset pattern with as few pieces as possible in order to avoid joins or seams in the work. Cut out the pattern pieces in a fine to medium calico and check that when sewn together they make a good fit without being pulled tight or put under any strain. The corset can then be made up in lace. I suggest using plastic boning, which can be stitched into place by machine, as this is the least visible option. This type of boning can be bought in black or white from good corsetry suppliers (see Suppliers, page 126).

Black Widow corset by Val Holmes.

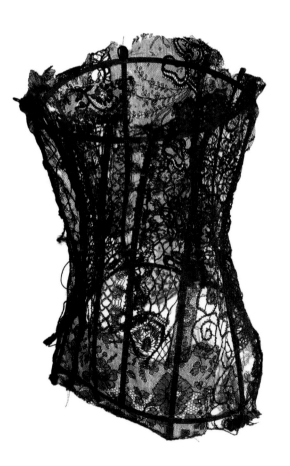

Black Widow corset

Something sexy and dangerous; the black widow tempts her partner and will then devour him. This corset, made with beautiful old lace is a little used and delicate. How many times has the Black Widow actually been widowed? Should we ask questions about who was responsible for the deaths of her partners? How many more will fall into her web?

Towards the end of the 19th century a new process of heat-forming industrially made corsets was introduced using heat and steam that gave the corsets a well-formed and almost permanent shape. If it is possible to have a tailor's dummy adjusted to the right size this is the ideal way forward (or at least a copy of this process) to create a permanently shaped corset that will be that much stronger.

It is the use of old, very delicate lace for this corset that makes it effectively unwearable. But

the techniques used could easily be employed to make a wearable corset. Do read through all of the instructions before embarking on your corset as there are a few decisions to be made in advance.

1. As outlined above, use a pattern with as few pieces as possible and make a toile as a try-out to make sure of a good fit without tight lacing and without any strain.

2. Redraw the pattern pieces on to water-soluble fabric, allowing for a 4mm overlap of pieces on the joining edges. I used a heavy plastic soluble (Romeo) for the starching it can give to a finished piece.

3. To produce the *Black Widow* I created a crazy patchwork of old pieces of lace, often leaving quite large gaps between them. These were stitched together with my own machine-made lace inspired by the patterns and motifs present in the old lace. Each piece of lace 'patchwork' was made to the size of one of the pattern pieces drawn out on the soluble fabric. Use interesting lace edgings at the top and bottom of each pattern piece as a finishing touch, or design your own lace edgings.

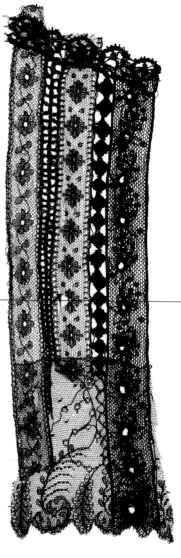

4. Cover the tailor's dummy with plastic wrap. Wash out the soluble fabric in cold water rather than hot water as this will help to retain some of the 'glue' or 'starch'. Place the wet pieces of corset directly on to the tailor's dummy, sticking them together where they overlap (the 4mm extra for seams). If you don't have a tailor's dummy perhaps you could try moulding it on to the person who will wear the corset and drying it gently with a hair dryer. If neither of these options is possible, wash the pieces out in hot water to take out all of the starch and produce a corset with a softer finish. Pin to a board or polystyrene to dry, making sure that you respect the size and shape of the pattern piece. It's a good idea to put a piece of baking parchment under the work to be sure that it does not stick to the board.

5. Once the pieces that have been more or less stuck together on the sculpted version are dry they can be stitched to reinforce them. If working with the 'soft' version, layer the pieces together using the extra 4mm seam allowance and stitch a double line of stitching at each side of the 4mm.

6. These seams can be reinforced and given form by stitching plastic boning into place. The plastic boning can be purchased with additional plastic caps for a better finish. So cut the plastic boning to the right length for each seam; cap both ends with the plastic caps; then stitch into place with a row of stitching. You may prefer to use two rows of stitching or a three-step straight stitch.

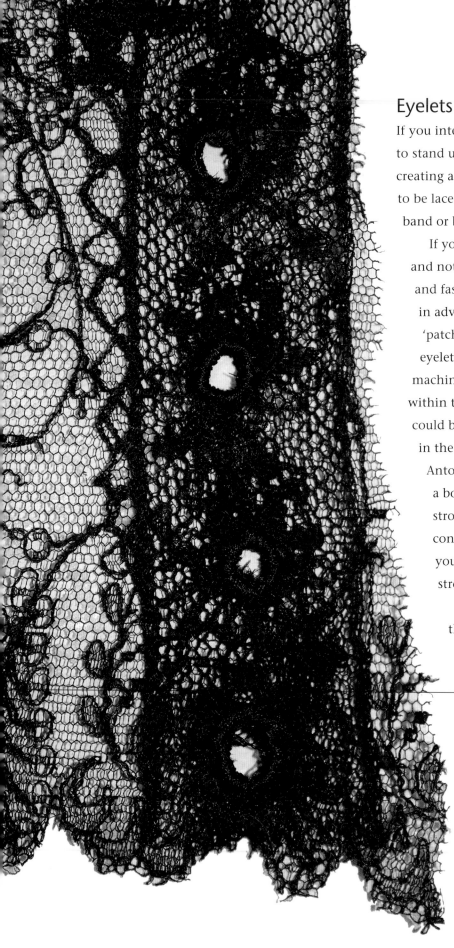

Eyelets

If you intend for the corset to be worn, and to stand up to a little wear, it may be worth creating a band of firmer fabric along the edges to be laced, if necessary reinforced with a metal band or busk.

If you prefer to make a fully lace corset and not include a busk or metal eyelets and fastenings, it will be worth planning in advance. When making the pieces of 'patchworked' lace that are to include the eyelets, stitch reinforced circles on the machine directly on to the existing lace or within the pattern of your own lace. These could be further reinforced with satin stitch, in the same way as the eyelets on Marie Antoinette's Jumps (see page 53). Choose a bought lace for these areas that is strong, perhaps a little dense, and in good condition. Alternatively, make sure that your own machine-made lace is quite strong and dense.

If the corset is for decoration, the eyelets and the corset will be under no strain whatsoever, so imitation hand-stitched eyelets can be made and sewn into place. See pages 36–37 for instructions.

Close-up showing the
machine-made eyelet holes.

Wearable corsets in plastic

Plastic bags can, of course, be pieced together to make traditional corsets from traditional patterns; but what is interesting about plastic is its ability to mould to a shape if heated. The inspiration for the following piece came from two sources. The first was my daughter's desire for something for a Rocky Horror Show fancy dress. The second was a few scraps of decorative braids picked up at a textile show from a stand selling couture leftovers – the bead and sequin neck piece, black plastic 'lace', and the fastening with eyelets and safety pins came from this unusual source and dictated the look of the bin-liner corset dress.

LBD (little black dress) or BLD (bin liner dress)

This corset dress is actually wearable, but more comfortable if worn over a cotton T-shirt as plastic doesn't exactly respire!

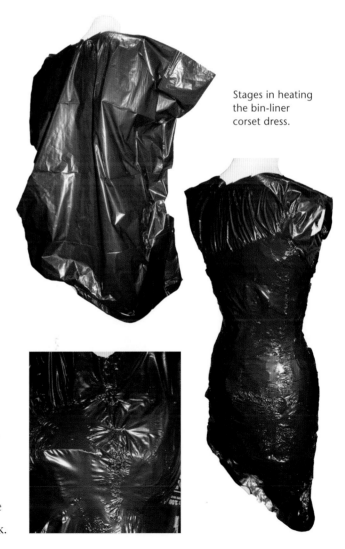

Stages in heating the bin-liner corset dress.

1. A tailor's dummy was covered with aluminium foil to protect it from the heat of the heat gun. The foil was moulded to the contours of the dummy as carefully as possible.

2. A heavy-duty plastic bin bag (100 litre size) was slipped over the dummy and gradually heated with a heat tool. The work was done steadily and carefully to allow for the plastic to take on the form of the dummy gradually, but not to become so hot as to melt completely. Under gentle heat the plastic bin bag gradually shrinks. This should be done with a mask on, and preferably outside or near an open window as the heated plastic creates unpleasant fumes. If done gently there shouldn't be any problems with fire risk, but it's always a good idea to have a bucket of water handy during this sort of work.

3. As the work progressed, holes were cut for the arms and neck, so that these too could be heated to form a 'finished' edge.

4. Once shrunk to the form of the dummy the centre back was cut and the beaded braid positioned along the neck edge with pins before taking the corset dress off the dummy. The beaded neck decoration was then sewn into place.

5. The braids along the centre back and the bottom edge were sewn on directly without pinning to avoid over wear of the plastic. All stitching was done with an ordinary straight stitch and a walking foot. A denim needle could have been used, but a topstitch needle worked fine.

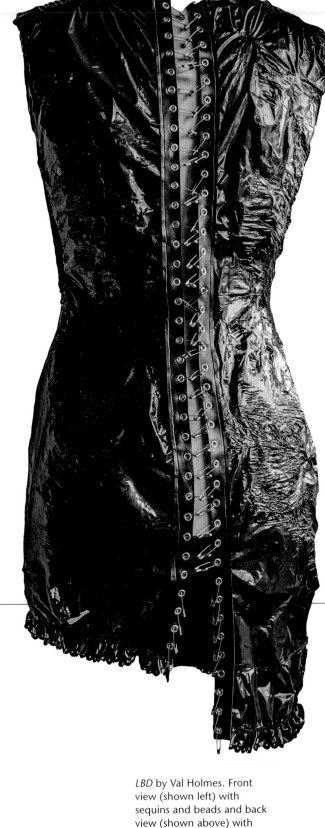

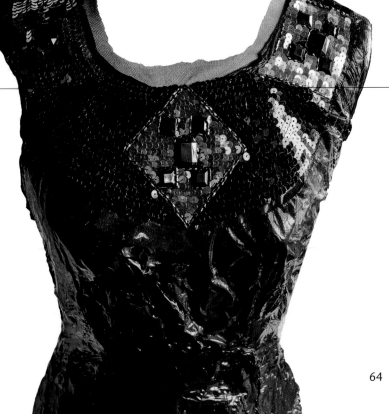

LBD by Val Holmes. Front view (shown left) with sequins and beads and back view (shown above) with safety-pin braid.

Siren of the Waves by Martine Amans

Martine's aim was to show the lightness of the waves and the foam of the
surf. The work on embroidered plastic bags was heated with a heat tool
to make the lace. Wool and other fibres were added with an embellisher
machine. The use of plastic to create the sea was a contradiction that
pleased the artist. Sea glass is included on wire.

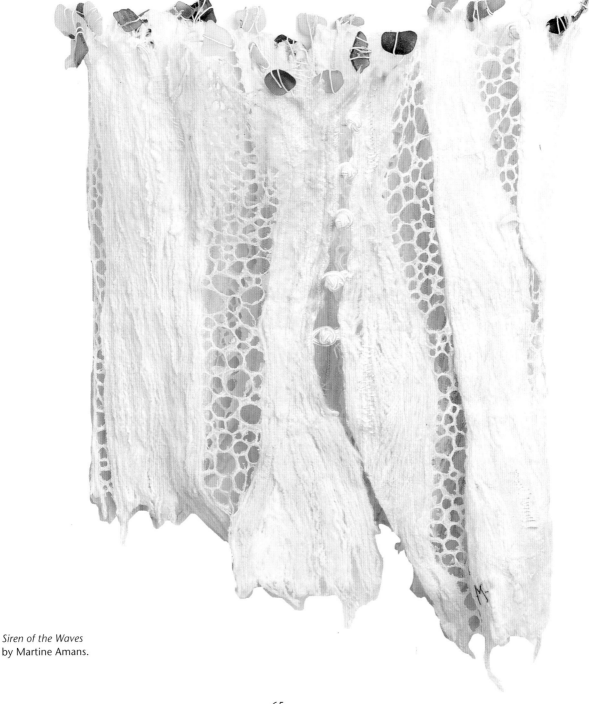

Siren of the Waves
by Martine Amans.

Wearable corsets in metal

The major difficulty with wearable corsets in metal is the obvious problem of making something reasonably comfortable. We can expect that a fully boned corset may feel a little like a straitjacket, but having uncomfortable bits of metal in your skin is something else.

Wire work

Working with wire is one solution as this will give and move with the wearer. It may be interesting to experiment with the following ideas using uncovered coloured wire or cotton-covered wire that you have dyed yourself.

○ Try weaving using wire as the warp and using a fairly thick thread as the weft. The resulting fabric could be moulded to make the corset shape as you work.

○ Working to an existing corset pattern drawn on to soluble fabric, stitch the wire to the fabric in such a way as to create a structure that will hold together.

○ The soluble fabric could have an embroidered lace created on to it before incorporating the wire that will give the structure to the corset.

○ Elements made with wire could be attached together to make a corset that it articulated. See the work of Diane Bates on page 102.

Working with metal to make a corset is possible. The following ideas could be tried.

○ If using fine aluminum, the type that is used in drinks cans, consider making a corset that is articulated, cutting strips or small shapes and stitching them together.

○ Perhaps they could be appliquéd to a soft surface for comfort. A corset could be made in felt for example, and then covered with a drinks-can appliqué.

○ The above ideas with tomato-paste tubes or bought fine metal strips will give a more supple result.

○ Using fine woven metal fabric, a corset can be made in the normal way, using a suitable pattern. The metal could be heated or coloured with acrylic inks, stitched and embroidered before the corset manufacture.

Burnt Corset by Val Holmes

This corset has a renaissance feel, somewhere between armour and rich lace, and if bras were burnt in the 20th century as a feminist gesture, perhaps our foremothers could have, or should have, burnt their corsets.

The steel fabric chosen was first heated over a gas flame to give interesting colours. To add further colour interest I placed the metal over synthetic organdie fabric. The work was then stitched together using a pattern taken from 17th century needlemade lace. Corset pieces were cut from the prepared metal cloth.

Other pieces for the corset were made from synthetic organdie 'lace'. To make this:

Burnt Corset and detail by Val Holmes. See also page 9.

1. Work on two or three layers of synthetic organdie layered together. Different colours can be used to add interest – consider how they look when layered.

2. Stitch a lace pattern that will hold together by machine with natural threads such as cotton, rayon or silk. The pattern used here is a simple grid, but any lacy construction will do. For security try to choose a design that would hold together if stitched on soluble fabric.

3. Pin the resultant fabric to a wooden board. This is essential as the fabric needs to be held tight for it to give and 'break' into holes to create the lace.

4. Using a heat tool, heat the fabric until it melts and holes form. The fabric will shrink back to the lines of stitching, thus creating a distressed lace effect. Stop the process when you are satisfied with the result.

Safety note: Wear a mask and work in a well-ventilated place. Do not bring the heat gun too close to the fabric.

Wearable corsets in paper

One way of creating wearable corsets that look like they are paper based is to use the transfer techniques given on page 28. Fabrics can thus be given a paper look and subsequently cut out and sewn together to make a normal fabric corset.

It is quite possible to create a wearable corset using the methods described in chapter one for moulding either a papier mâché corset or one made out of homemade paper. The best solution lies in the use of a two-sided corset that can be laced into place. The corset will not endure much wearing but will perhaps manage one or two special occasions. See Viviane Fontaine, page 110.

Working with moulded paper to make a wearable corset will produce something a little less fragile if it can be moulded on top of, or lined afterwards with, a pieced fabric corset. This way, even if the corset itself shows signs of breaking or tearing, the fabric lining will help to keep it together. The paper can be protected with acrylic wax if necessary which adds a suppleness that again can help against breakage and tearing.

Another solution is to work in a similar way to that employed for Nana's blue fabric corset (see page 56), appliquéing paper to a fabric ground in a patchwork style. The final corset could be coated with acrylic wax for a protective finish.

Slave to Chocolate corset

For some people to be actually cocooned in chocolate wrapping papers may seem like heaven. Our obsessional relationship with chocolate is explored in this corset, which is made up of sweet wrappers applied to a fabric base corset. The problem of keeping the slim body of our dreams whilst faced with the constant temptation of chocolate could perhaps be solved with a suitably constraining corset.

The appliqué is worked in machine-stitched words which explore the facts about chocolate and its production, including the use of child and slave labour, advertising slogans and references to women's relationship with chocolate. The many words become very difficult to read, stitched with a beautiful pink thread that the French would call Rose Bonbon.

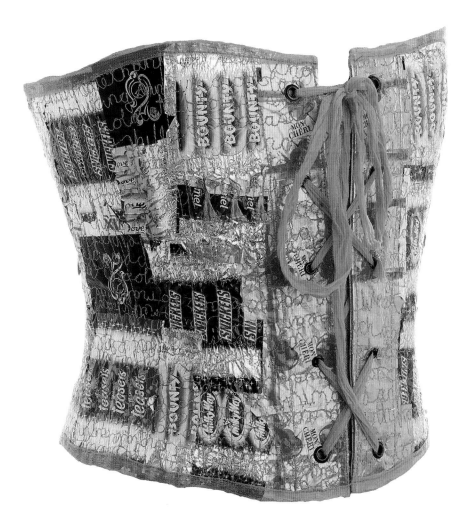

Slave to Chocolate corset
by Val Holmes.

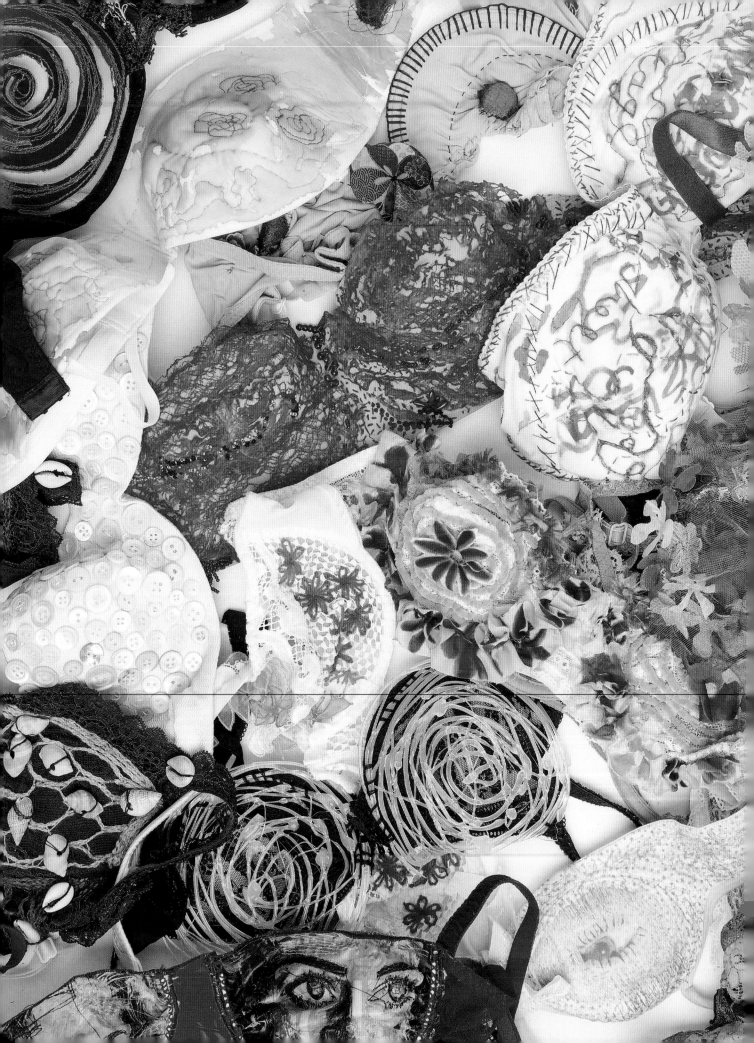

Bra-pod bags are fun and functional. What else can be made with a recycled bra? See page 78.

Approaches to Other Intimate Garments

Our relationship to the intimacy of our bodies, and the expression of that relationship, doesn't have to end with corsets. Underwear has been with us for centuries in various shapes and forms and can offer an interesting starting point for art pieces whether these be historical or contemporary.

Garments can be made from scratch or existing garments may be recycled or upcycled. Such work could be for fun or for meaning. Upcycling or reappropriating existing garments or garment pieces to make a statement or just have fun can really get the imagination going. Even collecting the garments in the first place can be way of raising awareness about ideas or a project. The completed piece worn or on show may cause even more discussion. Such projects can also be interesting if done collectively.

Working with real garments that have a history, real or imagined, can be inspiring. Creating histories for found garments can provide a starting point for rich research.

Nightshirts

The history of the nightshirt, pyjamas and the nightdress is not a simple one. Like most underclothes, the function of these garments has oscillated between hiding the body for prudery, protecting against the cold or revealing the body suggestively for the bedroom. Some of the hemp nightshirts I find in the local flea markets must have been a very effective contraceptive! But in some communities the nightshirt went even further, being used not only at night, but also as the daytime shirt, and yes, the same shirt worn almost constantly, with a fine cotton or linen shirt appearing perhaps only on Sundays. This close constant companion must have witnessed most of the life of its wearer.

Nightshirt by Marie-Thérèse Rondeau:
Homage to Seraphine de Senlis

An old, extremely harsh and particularly austere nightshirt found in a flea market in France begged the question, who could have worn such a garment? Would it have been worn in poverty, in a prison or psychiatric hospital early in the century?

Seraphine Louis, known as Seraphine de Senlis, was born in 1864. By the time she was 7 she had lost both of her parents and was brought up by her older sister until she could start to work firstly as a shepherdess and then housemaid. It is whilst working as a housemaid that she started to paint in isolation by the light of a candle. She painted bright, colourful paintings in a naïve style, with what is thought to be spiritual content, placing her imaginative flowers firmly between heaven, earth and their roots.

The collector Wilhelm Uhde discovered her in 1912, and gave her his support, enabling her to use real paint for the first time, but he was obliged to leave France in 1914 and didn't make contact with her again until 1927. This period was particularly difficult, but it didn't

stop her from painting. From 1927, with his help, she started to produce large pieces 2m (6½ft) high. From being very poor she suddenly had money, which she spent very quickly. By 1930 Uhde had stopped buying her work due the Great Depression. After so many riches and the thought of success, Seraphine, no longer selling her work, went insane and was interned in a psychiatric hospital in 1932, and from this time on she stopped painting. She died of hunger in the winter of 1942 under the harsh conditions of German occupation. In the same year her work was shown at Moma in New York in a group exhibition, and in 1945 she had a posthumous solo show in Paris.

The shirt by Marie-Thérèse Rondeau was first covered with a 'breakdown' silk-screen print with Procion dyes. The print was inspired by the flower motifs used in Seraphine's paintings. The embroidery is worked by machine on dissolvable fabric with floral images taken from the paintings. These are joyous and varied, covering the shirt as much as possible to forget its ugliness, as Seraphine must have painted to forget the poverty and ugliness of her own life. Feeling the need to add words or poetry to the shirt Marie-Thérèse explored the possibility of using poems about madness, but as she found nothing that she felt was suitable she used poems about nature.

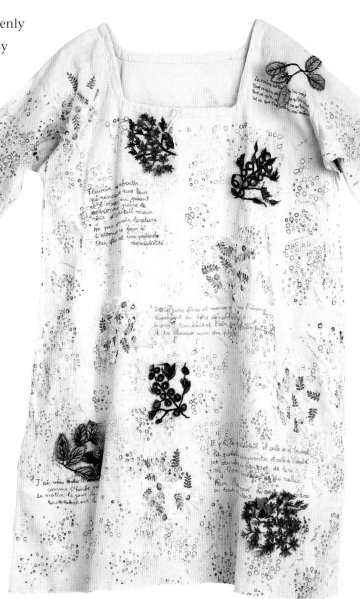

Homage to Seraphine de Senlis (shown above) and detail (shown right) by Marie-Thérèse Rondeau.

73

Nightshirt by Dany Pottier

This nightshirt was discovered amongst a pile of clothes and underwear left in the charity shop after someone's death. To respond to the nightshirt Dany Pottier imagined the life of the person who could have worn it: a daughter of the countryside. She noticed the patching and darning that must have been done for economy and imagined the wearer as a mother encircled by numerous children, breastfeeding the last child just until the next one arrived. Children who, in spite of their mother's huge fatigue, would have given her lots of joy. Dany imagines the children with their liberty to play and discover all the inventions offered by the countryside. The nightshirt has repairs by the owner as well as additional repairs worked by Dany with machine embroidery. The printed text is done with a thermofax print taken from writing in a school exercise book circa 1942, with today's moral message inculcating children to be economic and careful with their belongings.

Nightshirt (shown above) and detail (shown left) by Dany Pottier.

74

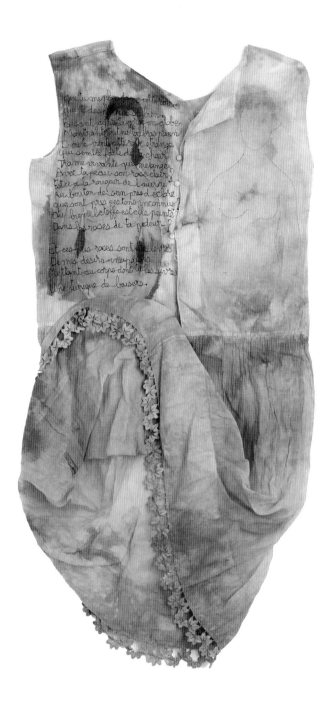

First Sentiments petticoat by Martine Amans

This old found petticoat was first dyed with Procion dyes and then machine embroidered. A photocopy print can be just seen through the petticoat, suggesting the nudity of the body underneath. The petticoat flicks up dangerously, revealing the adolescent underneath. But the owner of the petticoat is innocent, just as in the poem by Théophile Gautier which inspired this work.

First Sentiments by
Martine Amans.

Panties, knickers and bloomers

Working with existing garments can be fun and inspiring. Here, a group of women decided to use the most secret of garments as a starting point for an embroidery project. They decided to work on knickers in whatever way seemed appropriate, either in relation to the garments themselves, or with an influence from their other current artistic projects.

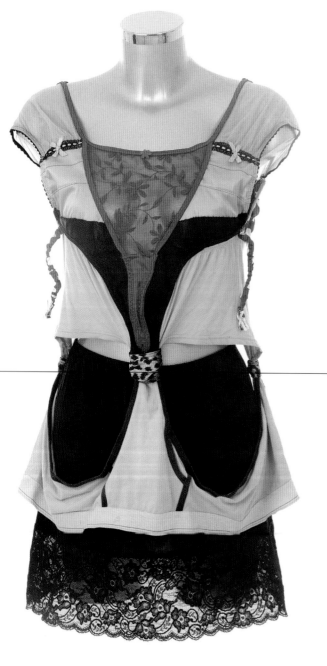

Knicker dresses by Julia Triston

Julia Triston has created a series of knicker dresses from donated underwear, which all bear the mark of the previous owner. The series came about after Julia was researching themes of gender and identity. These conceptual wearable artworks push the boundaries of textiles, and put on show what is usually unseen, by using underwear as outerwear. By deconstructing the underclothes, then reconstructing them into a 'new' garment, she changes their original meaning and function, and thus their identity. Julia's knicker dresses have been featured on catwalks and photo shoots.

Left: *Elle's Dress*, a knicker dress by Julia Triston.

Above: *Bloomers* and *Panties* by Claudia Boucard.

NETS collection
by Julia Triston

Julia Triston makes wearable garments that are upcycled from repurposed domestic materials. This outfit, entitled *Flower Power*, is one of three from her NETS collection (2010). In *Flower Power* fragments of underwear have been integrated and fused with reclaimed household linen and textiles to produce a three-piece outfit in which the delicate, lacy white materials convey a 'feminine' quality, and the wear of the textiles communicate an 'aged softness'.

Knicker bunting

Julia Triston creates installations from pre-worn underwear. Her strings of knicker bunting have travelled many miles and have been paraded on protests, shown in exhibitions, featured in carnivals, installed in bars, wrapped around monuments, used in celebrations, displayed at a fellow artist's funeral and filmed by the BBC.

Her first installation of knicker bunting, *Push my Button*, was created in 2008 and is 100m (109 yards) long. Each pair of knickers submitted for this piece was cut to form 'flags', weighted with a button and machined on to a continuous length of knicker elastic.

Many of the knickers submitted come with a significant story, and this forms the powerful narrative behind the work; the knicker bunting installations are an expression and display of 'real' women's' identities. From big pants and cami-knickers to tiny thongs and comfortable drawers, Julia Triston's installations celebrate the diversity of women's shapes, sizes and the choices we make about our underwear.

Above: *Flower Power* from the NETS collection by Julia Triston.

Below: *Push My Button* knicker bunting by Julia Triston.

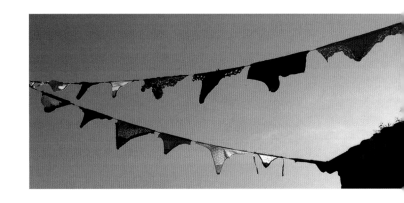

77

Bras

Working with existing garments can be fun and inspiring. Here a group of women decided to use bras as a starting point for an embroidery project. Bras can be sexy, supportive or confining, they can exaggerate, reveal what's there, make up for what isn't, be plain or colourful, smooth or lacy, an important part of everyday life or burned long ago with the advent of a feminist consciousness.

Altered, embroidered, painted and upcycled bras have been used for some years as a method of raising money and awareness for breast-cancer charities, and this awareness could be used to influence a collective project around the recycling of bras. Using this as a starting point, two of my embroidery groups decided to work on bras in whatever way seemed appropriate, either in relation to the bra itself and what that might mean to them, or relating to an influence from their current artistic projects.

A selection of bra pod bags
made by Julia Triston.

Bra-pod bags

Julia Triston's quirky bra-pod bags and purses are fun and functional items. Upcycled from bras, of all shapes and sizes, they are made to make a statement. The original features of adjustable straps and hook-and-eye fastenings are maintained; they perform the same purpose, but have a new identity and context.

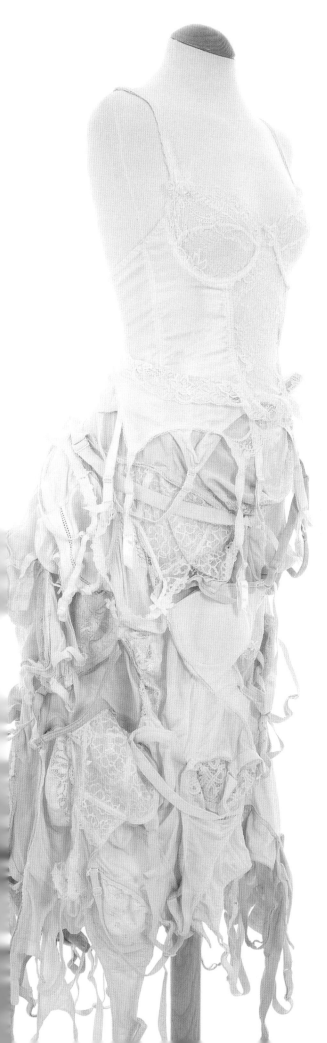

Bra-ra dresses by Julia Triston

Julia Triston's bra-ra dresses are constructed from donated, pre-worn bras. Each complex, conceptual garment tells a story and has a unique identity, referencing historical undergarments in its silhouette. This unique identity comes from the stories submitted with the donated underwear and the memories the second-hand undergarments hold.

Julia says 'I started using underwear as my main raw material a few years ago when I was producing pieces for an exhibition about identity. I wanted my work to have a powerful feminist message and to portray that we are all individuals and beautiful in our own way. As women we should be able to choose what we want to wear and when we want to wear it; why should we conform to what the media says our identity should be? What is usually unseen isn't always pretty, but it might be very comfortable! And I want to put this on show.'

We Fade to Grey bra-ra dress with bustle by Julia Triston.

Longline bra *La Vie en Rose* by Claudia Boucard.

The starting point for this piece was a vintage longline bra found in a flea market, almost worn out by time and wear. The owner had put on weight yet had continued to wear the bra which had extra bits added as time marched on. The satin had also been repaired. The song made famous by Edith Piaf seemed suitable as Claudia decided to cheer up the bra with embroidered roses. To conclude the work she hand stitched the words of the song kindly on to the bra. She says 'With each word embroidered, the words sang in my needle', and she imagined the generous proportions of the original wearer.

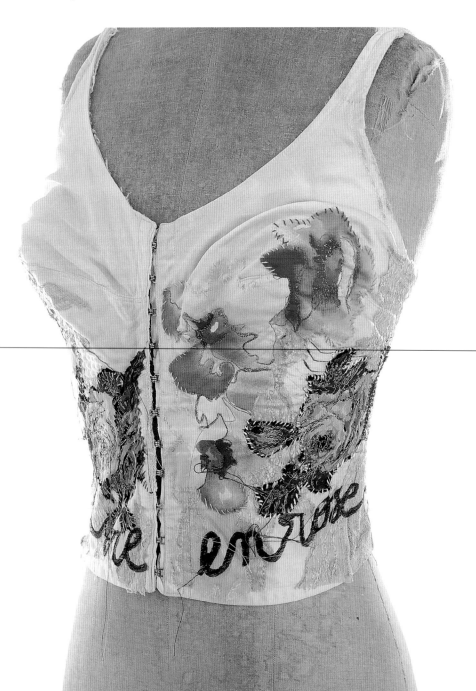

La Vie en Rose by Claudia Boucard. See also page 104.

Girdle corsetry: Writings on a Corset

I'm not quite sure if this type of support garment should be called a girdles or a corset, but I found one in a local charity shop and started stitching on it while in a show in Cholet in France. The event became quite fascinating as women gave me their personal experiences. I was surprised to find that a lot of young girls in France had worn types of corset between the ages of five and twelve as a method of acquiring a straight body shape. This practice had only ended around the end of the 1950s or early 1960s for some. The type of girdle that I was stitching on was meant for support, but was also used to hold up stockings, and was therefore largely used until the wide advent of tights during the 1960s. I also found myself talking to retired workers who had worked in the flourishing textile and corsetry industry around Cholet.

The corset is covered in contemporary quotes about corsets and their effects. Colour changes were made for each new quote, making it easier to read. Words that I decided needed particular emphasis are in red. Each quote is dated. The quotes were worked horizontally across the corset so that the corset could be displayed as a hanging.

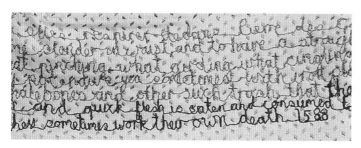

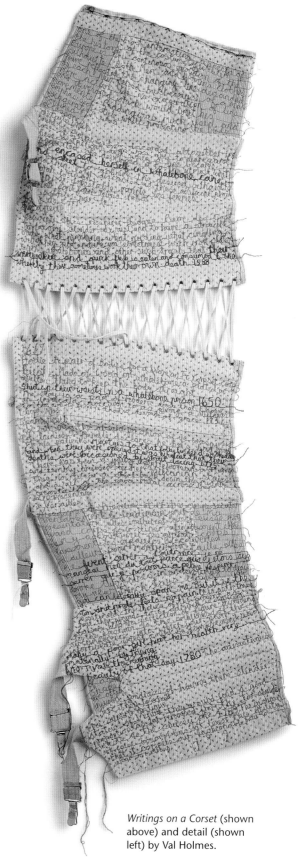

Writings on a Corset (shown above) and detail (shown left) by Val Holmes.

Collars

Collars were often pieces separate to the garment, added into place, or attached to the shirt at the moment of wearing, or at least on a fairly temporary basis. The shirt being, until the 20th century, considered as an undergarment, the collar was the only part of it on display. The expense of lace collars explains why they were removable items, but on more everyday wear they were removable because of requiring different washing conditions to that of the shirt, including, of course, heavy starching. It's sad to imagine that they would have been washed so much more regularly than the shirt itself.

Collar upcycling for bowl

I used a lace collar found in a fleamarket to make a decorative bowl. The piece was created as follows:

1. The collar was placed between two layers of water-soluble fabric (such as 'Romeo') for firmness.

2. The central space of the neck and the area between the collar sides was embroidered in red droplets.

3. Wire was placed along the edges of the red area and stitched into place with a free-motion satin stitch.

4. More wire was added with cream satin stitching, echoing the design, to reinforce the other areas of the bowl.

5. The piece was placed in cold water to ensure that some soluble fabric residue stayed in the fibres for extra stiffening. The bowl was then moulded over a stainless-steel bowl.

Collar bowl by
Val Holmes.

Once finished the conceptual resonance of the bowl seems multiple, so I haven't given it a title. The viewer can project his or her own reflections upon it.

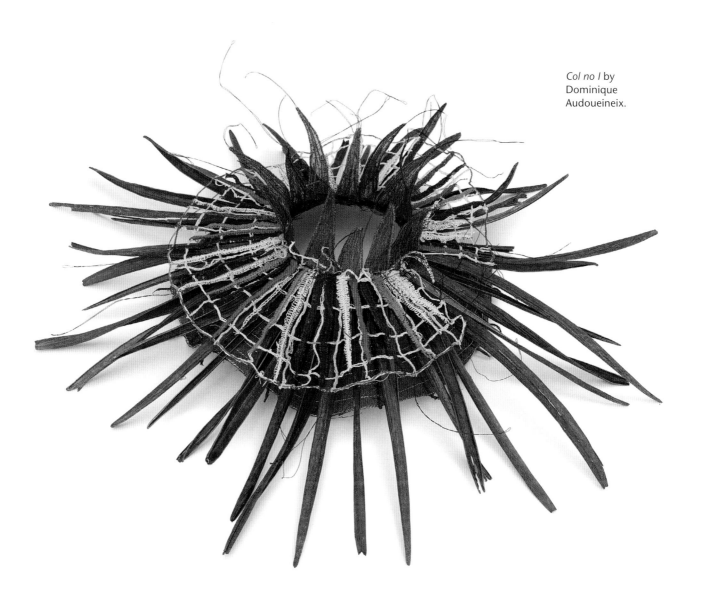

Col no I by Dominique Audoueineix.

Col no 1 by Dominique Audoueineix

Dominique is currently working on a series based on lace collars. *Col no 1* is made for a young girl and its subject is the way girls are, or were, brought up. The collar will prevent the person who is wearing from expressing herself as it will be difficult to talk or move very much. The collar will oblige the wearer to hold herself straight and will keep at a distance anyone wishing to communicate with her. The piece was developed after a series of complex studies and is constructed of needle-made lace and machine-made lace on water-soluble fabric. The armature is made from metal wire and catalpa seed pods are used as the spikes.

83

... La formule de Madame Bovary ... par exemple. Mais au pluriel féminités veut dire tant de choses et les dire avec tant de grâce et de harmonie ... note est une française et délicieusement française ...

la pudeur chez la femme doit être une grâce la plus, la plus charmante ...

en France la beauté n'a vraiment qu'une importance bien secondaire. Elle ne remarie ...

Ainsi à travers l'histoire, apparaît une sorte de féquilibre social, la femme perdant en respect véritable ce que sa beauté gagne en hommages. Ève nouvelle n'est donc pas si ... des politesses excessives qui sont simplement ... du désir brutal. La logique même du langage ... pas, en faisant de ce mot galanterie un vocable flatteur pour l'homme et injurieux pour la femme ...

Nouvelles Féminités
Marcel Prévost 1914

1934

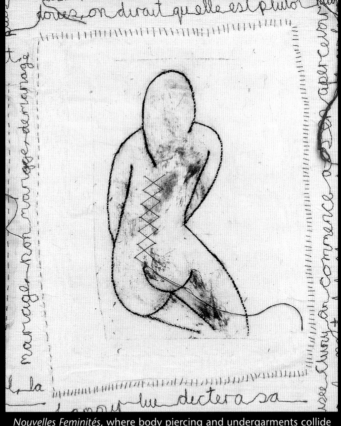

Nouvelles Feminités, where body piercing and undergarments collide (see page 95).

Two-dimensional Artworks Addressing Corsets and Other Undergarments

Creating works in two dimensions that reference clothes or elements of clothing can be a rich area of study. As discussed in the introduction, referencing clothing inevitably references the body that would wear, or would have worn the clothing, and as such the person concerned is very present or conspicuously absent.

Existing clothes or parts of clothing as a starting point

Contemporary, vintage or antique clothes may be a good starting point for studies of intimate clothing. Clothing could be used whole and flattened, literally cut in half to provide one face of a garment, or just one piece of the garment pattern could be used. Even in the latter case the notion of the garment shape will be present as well as that of the body that is absent from it. When using the whole garment, cut and flattened out, or presented with just one side to the viewer, there will nevertheless be a sense of the volume of the body that is pertinently missing.

Vintage Corset by Val Holmes.

Vintage Corset by Val Holmes

I found this corset in a flea market some years ago, and even incorporated it into a piece of work for a particular exhibition, but its aching beauty always astonishes me. The poverty of the former owner is so glaringly present in the repeated repairs. I eventually decided to recover it from its initial project and work on this piece, leaving the corset to really stand on its own. The only additions are:

1. The pattern pieces patched on; these obvious construction details are as fragile as the corset itself.
2. The X-ray between the lacing at the back of the corset. Tight corsetry can change the layout of the inside of the body, and cause strain on the bone structure. The X-ray is of a back with just a few problems (my own).
3. The red lacing on the back of the corset, holding the corset together and perhaps repairing the back, featured in the X-ray.

I have discussed previously the idea of artists referencing their own bodies as well as those of others when they do work about the body or the clothing that surrounds it. Our bodies deteriorate with age in the same way as this corset. Outward signs of wear and tear as well as the actual construction details of the corset and the body which start to fall apart. So the choice of this corset alongside an X-ray of my own back seemed like an appropriate relationship.

Vintage Corset detail by Val Holmes.

Working with garment pieces for inspiration

Working with real garments that have a history, real or invented, can be inspiring, and this is no less true if only part of the garment is used. The garment section can be incorporated into a piece of work, and the fact that the work will remain flat gives an opportunity for mixed media and complex techniques that may not be as feasible on a piece that is to be worn.

The clothing piece or pieces could be almost submerged under a layer of stitching, applied elements, paint or dye, painted elements such as painted Bondaweb, transfers, fibre or paper. The clothing piece or pieces could take centre stage in the work with little incorporation into a surrounding area. The clothing element itself could be worked heavily or lightly, but its essentiality retained.

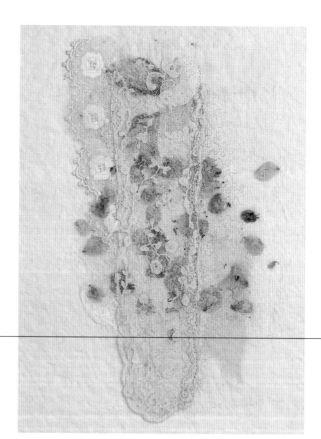

Above: Lace collar by Val Holmes. Part of a lace collar is featured with additional lace and machine embroidery on lightweight silk-fibre paper with rose-petal inclusions.

Left: Black vest front by Val Holmes. An old waistcoat front was mixed with parts of an embroidered shirt and additional lace. Rusted lace, scrim and additional paint were added.

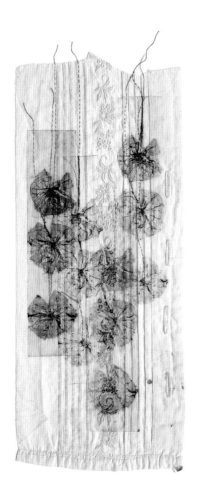

Our Grandmother's Flowers

I worked a number of pieces on this theme using the same symbolic reference, which moved between a notion of flowers and the representation of souls. The flowers are a symbol of death or mourning for these works. The collagraph print is made with paper 'flowers' varnished with button varnish to retain just the right amount of ink. The cardboard base for the collagraph plate was varnished with a shiny varnish that would wipe a little cleaner. Thus when inked up and printed the flowers print off more profoundly than the surrounding area. I have printed versions of this on handkerchiefs, which seems a very suitable support. This version is printed on to a vintage blouse front, twice in red and twice in black. Red running stitching in silk thread completes the work.

Left: *Our Grandmother's Flowers* by Val Holmes.

Below: *Violence* by Marie-Thérèse Rondeau, worked with hand and machine embroidery.

Violence by Marie-Thérèse Rondeau

This work came about through a series of chance encounters of old textiles shared between a group of women who work regularly together. From Monique came a piece of a shirt in broderie anglaise, which must have been fashionable in the 1950s. The shirt had obviously been worn a lot and was quite used. Marie-Thérèse found herself with half of a front. Dany, another lady in the group, had found some beautiful old linen in her mother's wardrobe that had never been used and was quite rough and stiff. My contribution was very simply to ask them to do something with the two pieces of old textile. Marie-Thérèse explains 'I fixed the delicate shirt front to the heavy linen, sewing into the torn areas, but I left the piece alone afterwards as it didn't inspire any further interest. When I found it some time later in a corner of my studio I started to study it. That day on the radio they were talking about violence to women. I was suddenly inspired and put myself to work. The result moves me by its realism.'

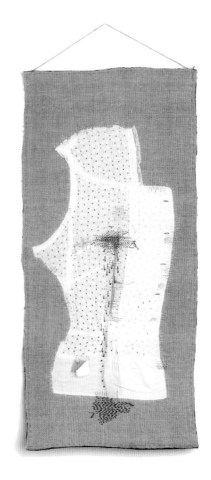

Referencing clothing through use of shape, drawing or notional elements

There are many ways in which clothing can be referenced without directly creating the item of clothing or using existing clothes. Here we are considering two-dimensional imagery which refers to clothing shape or parts of clothing.

Cutting out clothing shapes and using these as a springboard for referencing is an interesting way forward. There are many ways in which this idea could be explored. Consider some of the following:

○ Shapes could be worked in fabric only. Consider the type of fabric to be used. Pattern maker's toile cloth; vintage cloth or cloth that you have printed or embroidered could be cut to shape.

○ Shapes could be cut out of paper, or cut-out papers applied together to make a larger piece.

○ Incorporate recycled plastic, food wrappers, metal or natural objects such as leaves or petals.

○ Use the pattern pieces themselves. The fragile quality of traditional dressmaker's patterns has much to say. These could be incorporated with fabrics and perhaps other sewing notions.

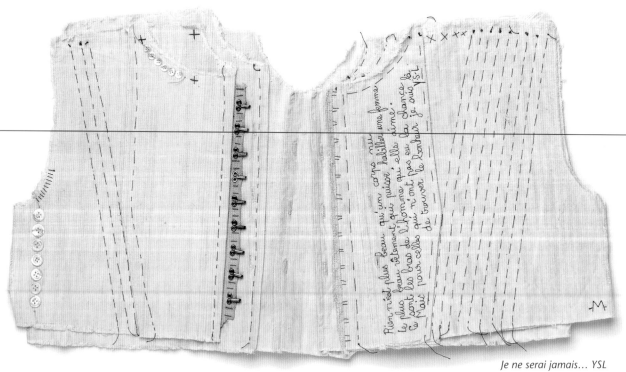

Je ne serai jamais… YSL
by Martine Amans.

Je ne serai jamais ... YSL by Martine Amans

The English translation of the title that I preferred to leave in French is 'I'll never be Yves Saint Laurent'.

This two-dimensional piece includes visual pattern-cutting references as well as sewing notions such as hooks and buttons. But is a long way from being a real garment.

After having seen the film with Pierre Niney and Guillaume Gallienne, Martine set to work. She worked on a fabric used to produce a toile given to her by a friend. Several layers of fabric were put together that had already been cut out. Then she tacked them here and there like a test garment that the designer would prepare before a fitting session with the placements of the boning and other fitting marks as well as the buttons and hook bands that could be used on the final garment. But, not being Yves Saint Laurent and not having his creative genius who, with just a few drapes and pins could create a garment, she stopped there. The writing is in machine embroidery.

The Wood Nymph's Corset

This two-dimensional 'corset', presented in a frame under glass, references several corset qualities such as the notion of boning in the use of dried lavender stems, embroidered on to the surface with a zigzag stitch, and the use of buttons, giving the idea of a closure. The corset is worked on embroidered cotton scrim with additions of 'gummy silk' paper and silk fibres punched in with an embellisher machine.

The Wood Nymph's Corset
by Val Holmes.

91

Clothing or underwear shapes may simply be drawn, printed or embroidered into the work, so only these shapes give reference to the clothing, pattern piece or underwear that is represented. Try the following:

○ Try some freehand drawing of underwear or clothing shapes on fabric. Simple drawing techniques with free-motion embroidery can be quite poignant.

○ Try stitching directly onto paper. Use a good-quality paper so that it won't break under the stitching, or back the paper first with an iron-on Vilene or fine fabric.

○ Try applying cut-out shapes in a different fabric to the backing then embroider the outlines and details.

○ Do the same on paper: use cut-out shapes from decorative papers or colour the shapes with crayons or paint.

○ Notice the different possibilities of scale. Work with a lifelike 1:1 scale, or draw miniature pieces, for example.

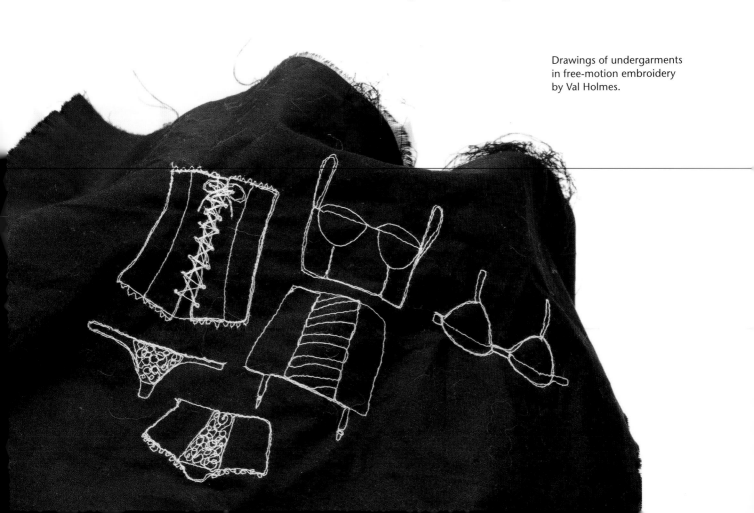

Drawings of undergarments in free-motion embroidery by Val Holmes.

Pages from Le Chouchou by Monique Joyeux

Monique found *Le Chouchou*, a catalogue of clothing in correspondence from the 3 Suisses dating from winter 1978 –79. Choosing the pages with lingerie, Monique started a collection of work in the manner of an altered book around the notion of women's bodies and intimate clothing. The pages were crumpled up to take away their glossy quality, and then flattened out again. Monique felt that things haven't changed at all since then. The women in the magazines were dolled up and clothed to be at their most seductive, but for Monique this is a trap as they then become only objects of desire. The threads of lace become the bars of a prison. Using machine embroidery and Calais lace, Monique reconstructed the images.

Pages from Le Chouchou by Monique Joyeux.

Collagraphy

Working with collagraph prints can be an interesting way to reference garments. Actual garments could be glued to a plate of cardboard, varnished with acrylic medium, inked up and printed.

The most important aspect to consider when using textiles and garments in collagraphy is how much ink is left on the plate for printing. If the print is to be a good one with relevant details of the garment, and not just a messy blob of ink, then choosing the right medium to protect the collagraph plate is essential.

Cloth will absorb huge amounts of button varnish, so it's not the best choice. An acrylic varnish or acrylic wax will give the best results. Between acrylic matt medium, acrylic wax and acrylic brilliant medium there is a choice of finish from matt to shiny, and they will retain different amounts of ink, from a lot in the first instance, to very little in the latter. The ink can be put on to the plate, but also wiped off with tarlatan or tissue paper to allow for the details of the garment to be really apparent. The print could be printed off on to paper or fabric. Embroidery could be added to the print if wished. For printing detail the best results are obtained with an etching press but patience and the back of a spoon running over the surface of the plate can work wonders if printing on to fine paper or cloth. For more details on collagraph printing see Further Reading (page 127).

Printed worn-out nightshirt front by Val Holmes.

Body piercing and the corset

When starting my research for this book I discovered there was quite a community tattooing and piercing their bodies to resemble the marks and stigma of actual corsets. I found the images quite shocking; the corset really did leave its imprint on the body. The first set of images I worked on this theme were from a collagraph print of a nude seen from the back. The collagraph plate is an embroidery on to a drinks can (shown right). The embroidery thread retains the ink and the drinks can is wiped perfectly clean of ink, or not, as desired. The advantage of this method of creating a collagraph plate is that it can be printed off easily by hand with a spoon on to fabric or fine paper. I printed the image in very dark blue and in colour. The corset ties were embroidered into the back of the nude-making a reference to a corset without the actual corset being drawn, and the idea that the corset lacings actually pierce the flesh of the nude becomes slowly apparent.

Corset I by Val Holmes. Collagraph print from machine-stitched beer can, with additional hand stitching.

94

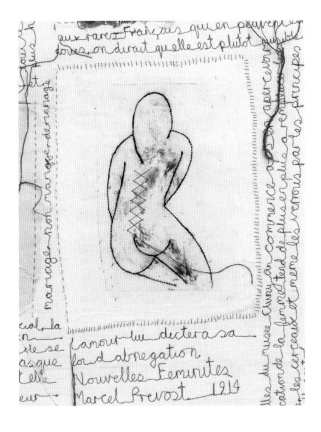

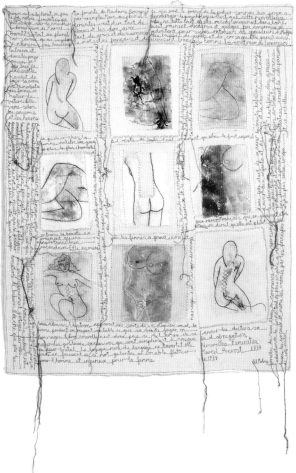

Hybridization

This project had a quite specific starting point. I was invited to participate in an exhibition of forty artists for which we had been asked to supply one piece of work on the theme of hybridization with specific size requirements for the finished work. During the exhibition there was to be a conference on body alteration and self-wounding. The previous work on the corset seemed like a good starting point. With nine collagraphs taken from my life drawings and printed on to my own paper, I constructed the piece. Some of the paper had lace included so these areas of lace were strategically placed in relation to the print. The prints were then stitched on to an old hemp/linen sheet background and bodily stigmata or repairs were added with hand stitching in red. To conclude I had found a book called *Nouvelles Feminités* written by Marcel Prevost in 1914 in a flea market, and I had started to use the book for my life drawing. I now decided to use the text for the background fabric; these texts are stitched in red, with the thread left hanging at every starting point so as to give clues as to how to read them. Through the writings of Marcel Prevost and my own interpretations I began to consider woman as a hybrid. Caught between wife and mother, lover or virgin, beauty or labourer, emancipated or submissive, a woman's psyche and form are in constant hybridization.

Nouvelles Feminités
(shown left) and detail
(above) by Val Holmes
(see also pages 84–85).

Notional elements

Notions play an important part in the description of a garment. The phrase sewing notions is intriguing, relegated to the bottom of the pattern envelope where the required zips, buttons, press studs and other bits and pieces are listed, and we imagine working our way through the old button and zip box left by our mothers or grandmothers to see if we can economise a few pence; or, on the contrary, look forward to the possibility of finding exciting buttons and add-ons for the new project. In corsetry and underwear these sewing notions become very specific and may even require specialist sourcing: closures, busks, zips, corset ties, lacing, buttons, suspenders, bra cups and underwiring are all used in the making of these garments.

Using these notional elements alone can actually imply the garment itself and we may become aware of the absence or presence of the clothing, and the absence or presence of the wearer through the simple use of sewing notions. These details on their own can really be quite evocative, but they could also be used with shapes that recall the missing garment or wearer.

In *Suspender*, a lone antique suspender is included in an embroidered panel stitched into a collagraph print. The print reminded me of a wall with peeling stucco. It's a pale version of a series of prints based on the idea of city streets. Here, with the lone suspender, we can imagine a sad image of a lone street walker – a lady of the night.

Suspender by Val Holmes. Collagraph print with embroidered gummy silk and antique suspender.

Life Drawing with Bra by Val Holmes.

Life Drawing with Bra

This unlikely piece came about from a fun afternoon working with a group of students when each person (myself included as my students like me to take up the silliest of my challenges) was asked to offer something unlikely and unfitting for another person to include in their current work project. I had just got back from a weekend of life drawing and was offered the bra underwiring complete with the lace attached. The colour and size was perfect for one particular life drawing, so I embroidered the drawing and added the bra piece.

Silk-paper corset

In another piece, the silk paper that I had made from silk-rod waste had such a corset shape that I decided to complete the image and add buttons and suspenders. The suspenders are vintage from the 1950s and were in fact new in a packet. As this didn't suit the idea they were artificially rusted.

Silk-paper corset by
Val Holmes.

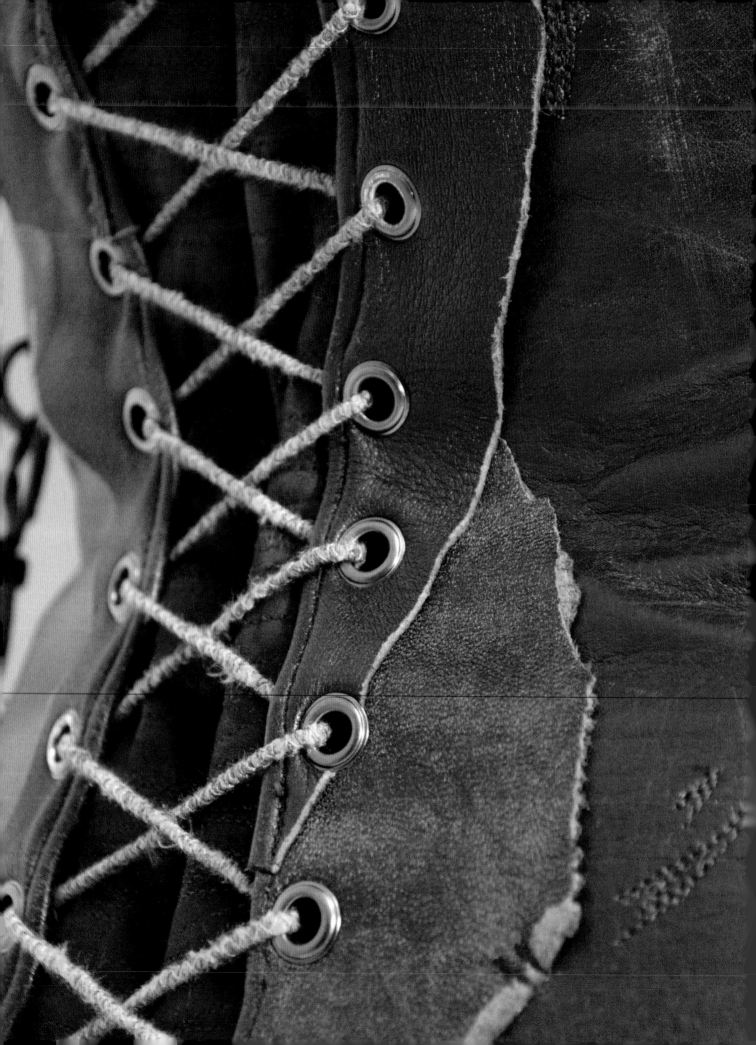

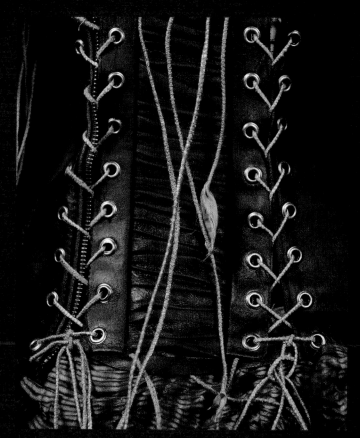

The working processes of others, such as these leather pieces by
Katherine Grimoldby, can help you conceptualize your own work.

Wearable Art
and Artworks by
Textile Artists

Throughout the book I have shown works by many different artists so that you may
become aware of the design and thought process behind each piece. Now we go a
little further, looking more closely at individual artists and their relation to corsets, or
specific questions relating to some of the work practices that have been explored.

Wearable art and artworks and installations by textile artists

Throughout the book I have shown many works by different artists and have asked each one to present their own pieces with their chosen words to describe the way in which they envisaged the work and how it was made. By doing so I hope that you may become aware of the design and thought process behind each piece of work, and perhaps the multiple ways of envisaging the process of design and conceptualization.

The thought process is essential in the creation of conceptual pieces and hopefully through looking at the thought processes experienced by others, it will help to construct a way of exploring this sort of practice for you. In some of the works the idea emerged little by little as the artist approached the materials and responded to them. In other pieces the artist had entirely conceived the work before even setting out. Titles and words, poems or songs have helped formulate ideas here and there, in other pieces the very nature of a technique or found object was the inspirational starting point for the finished piece.

In this chapter we go a little further, looking more closely at a few individual artists and their connections with corsets or underwear, or specific questions relating to some of the work practices that have been explored. Working with real garments that have a history, real or imagined, can be inspiring. Creating histories for found garments can provide a starting point for rich research.

Diane Bates

As an artist, drawing has always been an integral part of Diane Bates' identity, from childhood to art school. Being introduced to life drawing at 15 she found it challenging, yet exciting. But it was when she built her very first armature in the sculpture department at Goldsmith's College, London in the sixties that things changed. Diane was a student on the embroidery course, the head of department was the late Constance Howard, and she encouraged her students to work like artists. The armature was a very different experience from life drawing, where with some experience, various media, shading techniques and fancy mark making, you could give the illusion of three dimensions.

Elaborate pen drawings by Diane Bates are a starting point for her floral imagery and textile work.

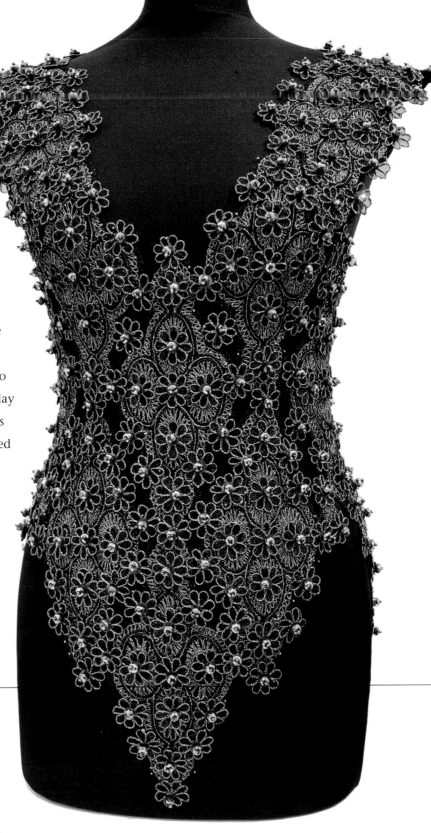

Corset by Diane Bates. Constructed using modules of flowers created with free-motion on fabric-covered wire worked on soluble fabric.

Constructing a linear, metal scaffolding structure from the life model was tough; there was no place to hide. The structure had to be accurate before applying the clay to progress to bronze casting. This valuable process not only informed Diane's life drawing and painting studies, but also brought a wider perspective to her textile work through choice of subject matter, scale, structure and combinations of untraditional textile media and processes.

It was when Diane was 50 during her full-time teaching as Senior Lecturer in the School of Art, Design and Textiles at Bradford College, West Yorkshire that she experienced something rather amazing. She had been revisiting a series of early drawings, selecting areas and developing some free-motion embroidery techniques in fragments. She then pinned, grafted and built these fragments onto a dressmaker's stand, this stand having formed part of a still life in her home for years. She remembers finding this new experience very engaging and exciting. It was only when Diane stood back

from the stand that she began to question her reactions. At Goldsmith's she never participated in the fashion and pattern-cutting classes because she was a plump girl and didn't feel comfortable making machine-embroidered embellished dresses for herself. But she gave herself a mini-tutorial, dismissing all of these negative thoughts, and began to realize that the process was more like sculpture. Almost an eclectic intermixture of expertise developed over the many years.

Diane gave herself permission to stop looking back and analyzing, and instead to follow her instincts, to experiment, enjoy and have the confidence to embrace this magical departure. Throughout the years this departure has enabled her to produce a large body of work called the Painted Lady Collection, each piece placing emphasis on the torso. Not having studied the history of corsetry, or been influenced by how they are made, she believes that what sets her investigations apart is her own drawings as a primary source. As a research tool these hold the key to each individual study, each having its own identity and story yet staying interconnected. This collection has featured in many national and international exhibitions, television programmes and publications. Diane doesn't sell any of this work, or take commissions, as it is important for her that this works stays as a collection to be seen as such by others in her lifetime and beyond as her legacy.

Looking at her current drawing studies and corsets entitled 'Putting on the Glitz', Diane feels that she is ready for a further departure. She wouldn't have done any of this work before she was 50, she just wasn't ready. She cannot invent any deep intellectual issues about the work, just a joy, passion and a love of this creative journey. Although Diane is not really sure of where it will lead, she is sure that the continual inner drive keeps her responding to the commitment and responsibility she has as an artist.

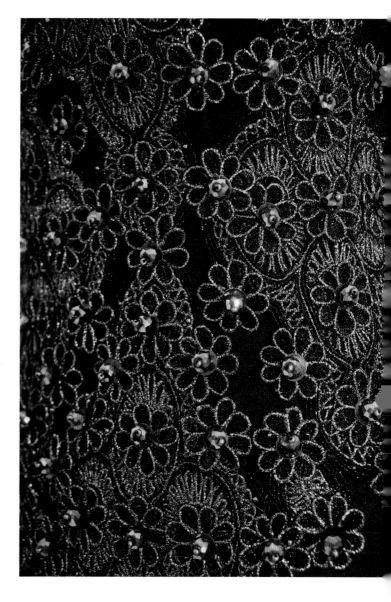

Close-up of the corset shown opposite by Diane Bates with machine-embroidered wired flowers and added beads.

Claudia Boucard

Claudia's work has frequently centred on the position of women in society, and she often uses the corset as a theme. She says she was born into a household that favoured equality between the sexes. As an adolescent she saw the position of women progress in society. Her parents helped her form her ideas; she was brought up with and surrounded by the notions of female emancipation.

As an adult, her maturity, her own way of looking at current affairs, her choice of reading and her many travels all feed into her artistic production.

During her travels Claudia has looked at and tried to analyse the position of women in Europe as well as in other countries and continents. She uses her art to express her thoughts, vindicate her ideas and defend the position of women, albeit with a certain amount of temerity, through her textile work.

One series of works is based on experiences in Morocco, a reflexion on the veiled woman, with the eyes of the woman through a djellaba or burka to express ideas of the submission of the woman.

As an antidote after this series, she felt she needed to lighten her thoughts through an exploration of the female nude hidden under the garments: using lightness and transparency to express the liberty of women or Women's Liberation. She says that in the West, we have been able to avoid these external wearable cages but that we have been equally trapped in another kind of cage called a corset.

La Vie en Rose by Claudia Boucard.

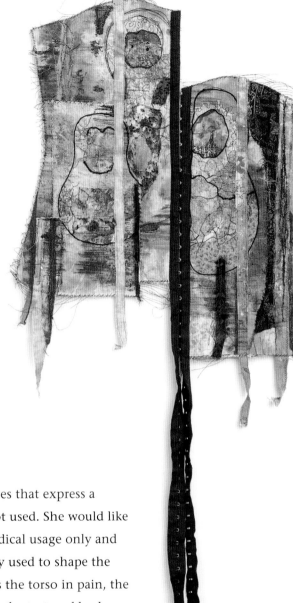

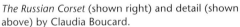
The Russian Corset (shown right) and detail (shown above) by Claudia Boucard.

Claudia finds that corsets are barbarous frivolities that express a corporal beauty. They deserve to be seen but not used. She would like to think that corsets have been relegated to medical usage only and no longer serve as an essential fashion accessory used to shape the body. When she works on a corset she imagines the torso in pain, the chest compressed and the ribbon tightening on the tortured back. She then tries to imagine these sufferings eased by using unsuitable materials, unreal for the confection of a working corset. It's her way of believing that they will never be worn but simply looked at or admired. Perhaps the use of a natural fibre can chase away the pain and soothe the spirit – see *Bark Corset* and *Abaca Corset* (page 44).

The Russian Corset is the story of the Russian dolls worked out from a series of drawings and collages. These dolls, boxed one inside the other, reinterpret maternity and here are placed within a flat corset pattern to symbolize femininity.

105

½ *Délicatesse* by
Claudia Boucard.

Plastic Corset

The *Plastic Corset* is closer
in fabrication to a real
corset (see page 46). The
tortured body is found in
the bands of plastic which
give way under heat and
are sculpted. Claudia used
colour and embroidery
to soothe the martyrized
body that would wear the
corset: her own way of softening all this brutality.

In ½ *Délicatesse* Claudia associated guipure lace with seaweed
collected near her home and carefully preserved. Working with
transparency and the fragility of the material she had to stitch very
carefully with the sewing machine. Giving herself difficult challenges
with each new project is what Claudia loves. As she stitched she noticed
the difference between young vigorous seaweed, fine, vulnerable and
easily torn under the machine, and the mature seaweed which was thick
and difficult and resistant to stitch: an obvious metaphor of the female
body under the corset.

In the finished piece, held between plastic for preservation, but also
so that it can be appreciated in transparency, the threads have been left
uncut as they form a part of the story, the link between the drawing, the
embroidery and the seaweed.

Claudia hopes that her corsets will be judged for their art and not for
their cruel conception of maintaining and caging the figure.

Julia Triston

The theme of Julia's textile artwork explores and investigates perceptions of identity. She is interested in deconstructivism, and the key concepts which link the disciplines of fashion, art, gender and sustainability. She believes strongly in the ethos of upcycling; the bulk of her raw materials are donated, and include vintage lace, reclaimed household linen, discarded embroideries, second-hand clothing and previously worn underwear.

Julia is fascinated with the journey textiles take. She feels that every piece she works with holds memories of its original purpose and function. Each mark, stain, crease, tear or frayed edge can tell a story of fond and constant use, or neglect and deterioration. Highlighting the wear and tear of the fabrics she works with is important and is a reminder of the original identity of the cloth.

In her working process Julia considers how to re-piece, re-vitalise and restore a new identity into worn and loved materials that have been marked by the owner, by the wearer and by time. She starts by analyzing the raw materials, studying the 'landmarks of construction' within them (seams, buttons, zips, motifs, rips, eyelets…). She then deconstructs the original garments or cloths and reconstructs new pieces (sometimes two dimensionally, sometimes three dimensionally), changing their function and identity: knickers can become bunting, bras epaulettes, crocheted doilies panels in jackets (see pages 76–79).

Julia works spontaneously with the deconstructed components: piecing, layering, connecting, pinning, stitching, inserting, adding or taking away, re-piecing, re-pinning, and re-building her surfaces and forms. Her knicker dresses and bra-ra dresses are constructed on a mannequin. She constantly considers the overall composition and balance of the materials, and their relationship with each other, and makes

Pink Nation bra-ra dress (detail) by Julia Triston.

sure the proportions and spaces all have a purpose; every piece added (or taken away) has to be justified. Quite often her construction stitches are invisible: the identity of her materials, in their new form, make the statement that she intended.

Julia's two-dimensional pieces are abstract assemblages. She integrates and fuses details and fragments of fastenings, clips and straps with raw edges, inside-out seams, tears, marks and fraying to become features and new landmarks in these pieces.

Julia's three-dimensional pieces are wearable garments and installations, often referencing historical underclothes and forms (such as bustles, voids, lacing and splits) in their silhouettes. These pieces are designed to challenge the concepts, attitudes and boundaries that define art and fashion, and clothing and dressing the body. Donations of underwear come with a story, which form an integral part of the feminist narrative behind her work. The stories received have been funny, moving, intriguing and full of memories and comments on how our bodies change over the years. One personal story about breast cancer prompted the creation of her *Pink Nation* bra-ra dress, which she wore on the Fourth Plinth in Trafalgar Square as part of Antony Gormley's 'One & Other' project.

Every item of underwear that she uses has its own intimate history and identity and an association with its wearer. She says 'My aim through using pre-worn underwear is to push the boundaries of art textiles, to put on display that which is usually unseen, and to make a feminist statement that gives women, whose voices may not otherwise be heard, a platform to speak through my art.'

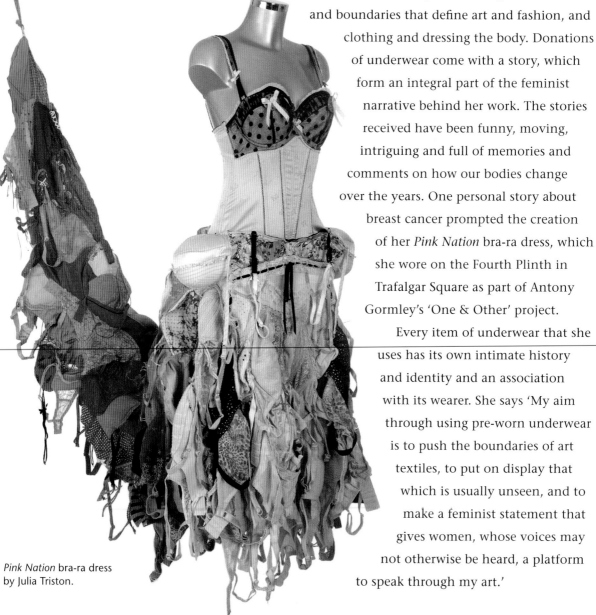

Pink Nation bra-ra dress by Julia Triston.

Seams of Identity Series II

Seams of Identity Series II
by Julia Triston.

These two-dimensional artworks, created by Julia Triston, explore
the code of dress and the memories held in everyday textiles. Julia has
deconstructed second-hand clothing, school uniforms, underwear, vintage
lace and bed linen then re-pieced and re-built these components into
collaged assemblages with new identities.

Fragments of fastenings, seams and raw edges hint at previous
functions and memories, and the 'shaping' of the new pieces resembles
the lines of boning in corsets.

She says 'I am interested in the marks, stains, tracery of stitching, and
signs of wear and tear from the original items; I intentionally make these
features and landmarks in the new pieces. These original details signify a
new message to be interpreted by the viewer.'

Viviane Fontaine

Paper histories and stories

Paper is a passion that goes back more than 40 years for Viviane Fontaine. In 1972 she had her first contact with paper as an artistic medium with a well-known artist in California, Dominic di Marc. She can still remember the box with bits of paper that he made in a very haphazard fashion. These small bits of almost nothing, so beautiful and precious, caused a surge of emotion that was to stay with Viviane. She had taken the chance to visit the USA in 1972 as a gap year before continuing her studies. She hadn't imagined how much the meeting with Dominic di Mare was going to impact on her working practice.

Back in Switzerland she joined a Fine Art course, and in the last year of her studies she thought once again about what she had seen in California. It had taken three years for paper to speak to her, but it has been with her ever since. The first step was to try to create a paper suitable for the drawing that was important to her work. But it wasn't as simple as that. A kitchen liquidiser helped to transform bits of cloth, but this was just the start.

Cloth for clothing or sheets is transformed and woven in order to be used; once this cloth is too worn out to be useful it is traditionally collected and taken to paper mills to be mashed up and used to make sheets of paper. The cloth is reborn in this new form. Viviane saw a parallel with our own existence, the paper being a symbol of civilisation and at the origin of civilisation, the sharing of knowledge. The philosophical side of her research interested her, the alchemy of the paper captivated her, and in her first works she tried to capture this ephemeral instant of the passage between cloth and paper.

In 1979 she bought a small Hollander Beater of the type used in industry since the 18th century to professionalize her paper manufacture from cloth. A few years later she started to work directly with plants.

As time goes on Viviane experiments and discovers new techniques. For example, leaving plants in water and stirring them from time to time will create quite a different result from cooking the fibres. She also discovered that the sun alone can whiten certain fibres such as nettle or mulberry leaves.

Paper Wedding Dress corset
by Viviane Fontaine.

Viviane's first visit to Japan in 1987 was a revelation, followed by five further visits. She was able to meet and learn with a master paper maker and learn the technique of 'washi' Japanese paper. This craft is extremely technical and the learning of it (one year for a perfect sheet of paper) opened Viviane's eyes to new horizons for her own work. Washi is obtained by ejecting the fibre from the frame in a series of waves, whereas western paper is made by accumulating the fibre in the frame. These two modes of expression form the difference between the Orient and the West, and it was this difference that fascinated Viviane – Japanese paper which reflects light, or Western cloth paper which captures it. The added ingredient of vegetable matter opened even more doorways and enriched her palette possibilities.

Viviane sees her work as having two aspects. In the first she is working with materials, surfaces that have a relief, layers superposed just like old memories. The paper as a support for writing, a skin into which is inscribed the passage of time. Old walls and books suggest different directions the work may lead to. Meanings are literally hidden in the nuanced layers. Writing and colours add soul to the work, the writing is unreadable so that the words keep their discretion.

Paper Wedding Dress corset (detail) by Viviane Fontaine.

In contrast to this work of accumulation and layers is the work of airiness and transparency, bringing in light through techniques that require extreme care, sometimes just keeping the skeleton of the plant, its very soul, teaching the force and fragility of all living creatures. The themes that she works on can be very different: bowls, small and large, books, walls, and most especially clothes.

Clothing has always formed a centre of interest and through all these years Viviane has continued to create clothes for imaginary beings. From coats made of leaves, kimonos in mulberry, a dress in rag paper to a collection for the opera Hansel and Gretel in 2010. She was also commissioned to make a wedding dress in mulberry and gampi paper.

Viviane's artistic route is so much a part of her life that the two are inseparable.

Cherrilyn Tyler

Underwear revisited

Cherrilyn has always been fascinated by underwear – the beautiful, hidden garments that structure our shape. She wanted to take these garments and create work that represented the wearer, the femininity that can seem fragile but is actually strong. Her work is washable by hand, and the nets and webs that she creates have strength because of the reliance of each material on the other.

Cherrilyn became interested in the suffrage movement: how women singularly were relatively weak but together they had strength to change the world. It is this joining together of thread creating a strong fabric that appears fragile that underpins her work. Her early work used silk fibres to create a 'paper' that appears delicate but is strong (you cannot tear it) and on to this she machine stitched and painted the surface decoration.

As she moved on, it was the fabrics of underwear –-the lace and net – that she wanted to convey as a vehicle representing the grouping together of women to be strong while appearing delicate and insubstantial.

Lately her work has touched on how women would have felt being corseted; why they had to have whalebones to shape their bodies when their own bones formed their structure. It was the play on words of lace – 'lacing too tight' that she used for one of the pieces.

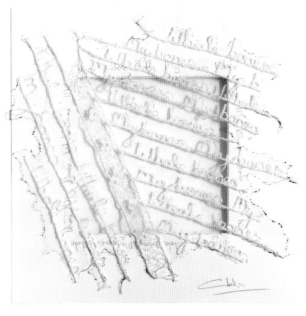

Whale Bone My Bone by Cherrilyn Tyler is about the conflict of emotions. The human shape is defined by bone structure, why do you have imposed upon you another shape using whalebone?

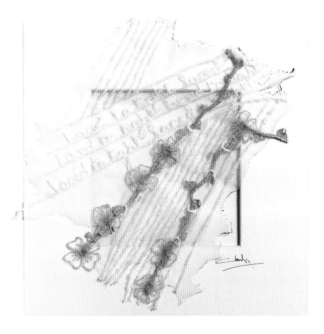

Too Hard Soft by Cherrilyn Tyler debates the question of the soft female form being restructured by hard whalebone.

113

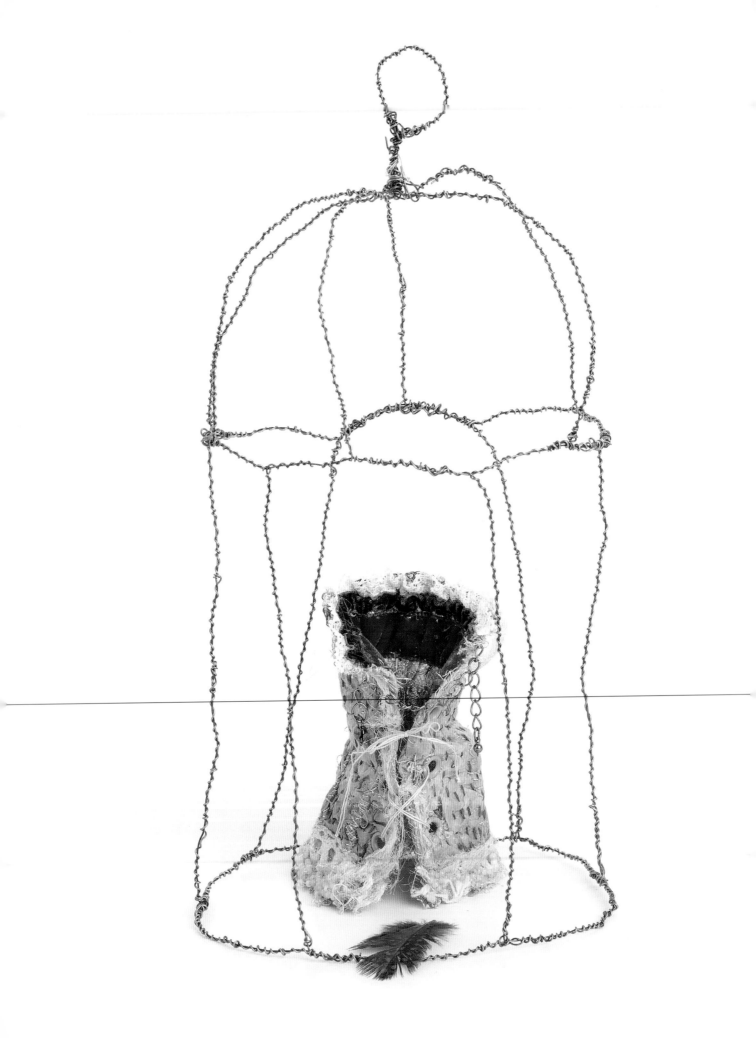

Shirlee McGuire

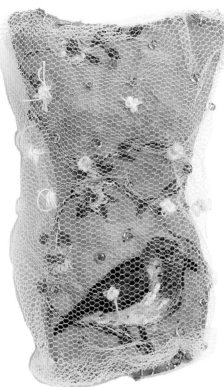

Miniature Paper Corset by Shirlee McGuire.

Originally from London, Shirlee now lives and works in Cumbria and uses the surrounding area of the Lake District as a never-ending source of inspiration. Having obtained a degree in Contemporary Applied Art, she went on to do a teaching degree and now exhibits and sells work through various galleries throughout the country and conducts workshops in textile-based techniques.

As well as nature her work is often inspired by history, literature and film and it is through the investigation of these subjects that Shirlee begins to visualize finished pieces. She uses mostly vintage materials, old book pages and found objects to create pieces that are of interest to her. She feels that by covering a wide spectrum of interests she has the scope to create art without boundaries, and the process of using embroidery connects her to the work like no other medium and creates the texture and depth that she needs.

Shirlee often returns to making pieces in miniature which developed through her interest in miniature portrait painting. The idea of being able to hold a portrait or a sculptural piece of art in the palm of one's hand holds a special fascination for her.

She enjoys exploring and reinventing an object in miniature, allowing the work and what it represents to be viewed in a different and interesting way.

Shirlee has made several works on the subject of corsets. She feels that the juxtaposition of beauty and restriction allows her to explore how these two things manifest and become one. This unnatural and restrictive piece of clothing is hidden from view yet is visible through its overall effect on a woman's movement and demeanour.

Left: *One Day I'll Fly Away* by Shirlee McGuire. Paper corset and wire cage. Paper and lace, hand-stitched piece in hand-twisted wire cage.

Using paper as a medium gives the work its fragility and by stitching into it turns this fragility into strength, allowing the work to stand as testimony to beauty, bravery and ultimately endurance.

Martine Amans

Passionate about both reading and textiles, Martine rapidly came to associate the two in her work practice. Her interest in books, reading, poems and song lyrics informs and inspires her imagination and her textile work. By incorporating text in her textiles she may be a messenger, sharing a poem or text that has had an emotional effect on her. She hopes that the viewer will discover the possibilities of the emotion through the included text.

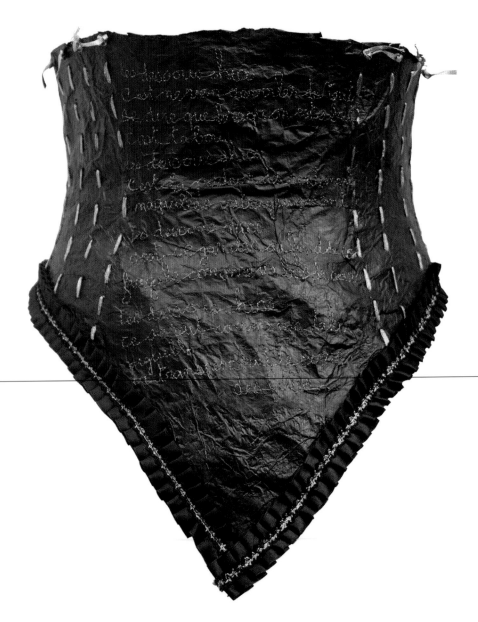

Les Dessous Chics by Martine Amans. Paper moulded on a mannequin support, machine embroidered with the words of a song. Ribbons and lace have been added.

Although the text carries the emotional content that has inspired Martine in the first place, the emotional content that she wishes to share – the texts – also have a graphic quality in the way in which they are reproduced. Like drawn lines and movements that animate the surface of her work, the words or methods she uses to transmit them are not always totally visible. The writing may be worked in the same colour as the background, or with a breakdown print that makes it barely decipherable. In such cases the viewer will have to be more curious to work out and follow the signs, or equally ignore the actual text and concentrate simply on the graphic quality that is produced.

Martine believes that the writing adds to her work, and she doesn't include it without thought, incorporating it into the planning of the work and the response to the textile or paper surfaces involved.

For Martine simply reading something, a text, a poem, a novel… can inspire a textile creation, but the reverse can also be true: she may be working on a theme in her textile practice that requires more information, that will grow in richness if there is background study. Thus she finds another reason to plunge into more reading and research. For Martine text and textile are infinitely and completely linked.

The poem on the pink petticoat (page 75) is by Theophile Gauthier; the title and text for *Je ne serai jamais … Yves St Laurent* (page 90) came from a biography, and the corset shown here is embroidered with the words of a Serge Gainsbourg song, 'Les Dessous Chics'.

Les Dessous Chics (detail of back) by Martine Amans.

117

Katherine Grimoldby

Katherine graduated from the University of Cumbria in 2013, where her studies drew her to wearable art. Playful experimentation with leathers and dyed silks spiralled out of control, resulting in a collection of ensembles that references historical costume, natural forms and pop culture's 'warrior woman'. The upcyled leathers have been transformed into fantastical exoskeletons that augment the body. The corset provides the foundation for this concept. Katherine says, 'No other garment is as fascinating nor dichotomous in nature. In short, choosing to wear a corset in the 21st century is a statement. It signifies assertiveness and sensuality, while providing a physical support much like an embrace. It could be said that a corset is a woman's armour. One has only to observe early surgical corsets and steel corset covers to draw visual comparisons. Even examples of 15th century European plate armour accentuate and fetishise the waist. The corset prevails, quintessentially feminine, and fierce.'

Leather possesses a unique, contradictory vocabulary: sophisticated, savage, refined, raw, luxurious or utilitarian. Early in the project, Kat made the conscious decision to use only recycled materials in her collection. Her leathers were salvaged and stripped from existing garments, eliminating the fear of the blank canvas, as the materials suggested shapes and forms of their own. A pocket, a perforated seam, a zip edge, a stud: all became involved in the aesthetic qualities of the new, fantastical garments. Initially, the use of leather in this collection referenced fetish culture, but it also conveys the concept of a second skin. The top grain has a slight sheen, much like shell or horn, while the suede in contrast is softer, almost bark-like.

Through extensive sampling, Katherine has found fresh techniques and approaches to her materials. Irregular tucking and pleating of the leather has become a prevalent motif that unifies the ensembles. Soft dress-weight leathers are manipulated into protuberant ridges that segment like vertebrae, slithering up gauntlets, sprouting from the shoulders, and sweeping over the hips. Each panel is constructed independently to a rough pattern and stitched together using an industrial sewing machine

118

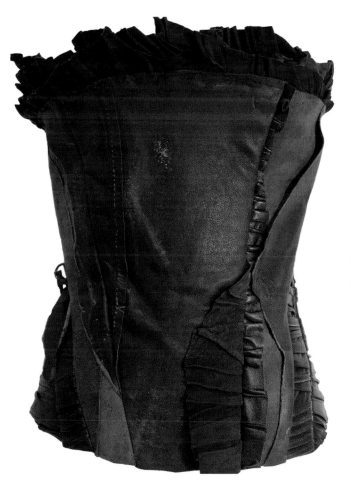

with, of course, after much trial and error, a few broken needles and, according to Katherine, many, many profanities. As opposed to traditional boning, Katherine uses layers of stiff interfacing to create structure and rigidity in her garments. The panels are laced into position with braided silk cords, referencing kumihimo that fastened the components of Japanese samurai armour.

Tearing the leathers provides unpredictable, inimitable results: soft organic lines that break up the formal structure of the corset, spilling over seams like ruffles and lace. Surfaces are softened with sandpaper, and darned with a patina of stitch and free-machine embroidery to create depth and texture. These nicks and gouges are implicit of battle-beaten armour, but also soften the overall aesthetic of the garment.

Some bodices have been constructed more sporadically, resulting in a more organic aesthetic. Through boiling, and sewing tucks at random on both sides of the leather, Katherine has created a myriad of specimens, which transform when affixed to the dress form. Gradually, through hand stitching each piece of boiled and tucked leather to a sinamay under-structure, a pleasing composition has been achieved. A patchwork of leathers which ripple and cascade across the form like tree bark. This practical experimentation is accompanied by constant dialogue of drawing and photography.

Corset (left) and
detail (above) by
Katherine Grimoldby.

Karen Frost

Karen Frost is a textile artist who gained her City and Guilds Diploma in 2005. Her research subject for design was tudor costume; she feels she has an affinity for texture and the way the Tudors worked and the need to keep their old crafts and skills alive. When working to a theme she finds it useful to start with a story – this is her way of starting the journey on the road to creating and finding the inspiration for a design. This story begins with her love of books as a child about fairies in any form, the magic and make believe.

Titania's Corset

Underwear – light and ethereal with a little extra hidden magic. Cobweb, Mustard Seed and Moth were given the task to make a garment to go under Titania's diaphanous cloak for the Midsummer Night's Ball. The fairies

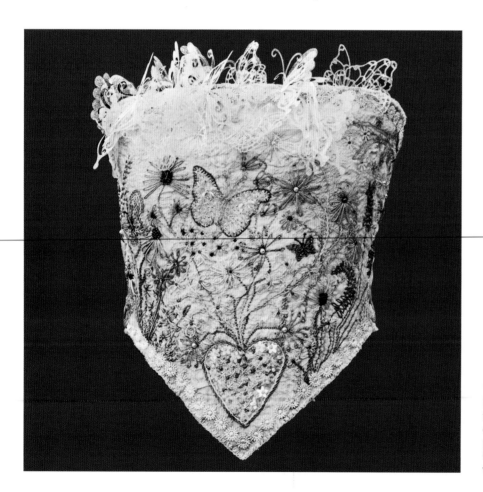

Titania's Corset by Karen Frost (left) and detail of the stitching (right). Hand embroidery on lightly painted silk with lace moth border cut from sheer fabrics with a soldering iron.

discuss their plan of action: silk, as it is for the Queen of the Fairies, to be embellished with embroidery and to include beads of sparkle and magic. They themselves will be hidden within the garment; Moth is invisible, Cobweb will spin a web of silver thread and Mustard Seed will sprinkle a shower of fairy dust over the mystical hare. The garment is to include delicate flowers, the Dream Tree to make your wishes come true, toadstools and a Heart of Romance.

The fabric is of white silk – painted with diluted silk paint to give a very delicate hint of colour. Karen used the embellisher to bring the silk and the wadding together as a foundation to work on. Using this method gives a raised texture, a look like that of seersucker. Boning is incorporated between the foundation fabric and lining and the lacing has been strengthened with an insert of silver leather. The corset is of a Tudor design with a little intrusion of the 21st century. The corset was used to flatten and raise the bustline and could be laced from the front or back. If it was laced from the back then the owner must have had a servant to draw it together. Karen made a pattern by pinning and cutting fabric to fit the body form until it resembled a corset taken from her research; in this way she obtained a perfect fit.

The corset has been hand stitched as a Tudor would have worked, with embroidery of chain, stem, blanket and back stitch, French knots and many other stitches. With all these stitches it is possible to experiment with lengthening and detaching them, giving no rules to work to. Karen doesn't work to any plan: she allowed herself to be influenced by the colour of the background fabric to choose the colour of thread and then fill in with the design she wished to create. Working with no given plan doesn't always work. Karen says, 'If the colour is wrong or the embroidery stitch just not right, you learn from this to move on and not give up – this is the challenge and the "what if" scenario. Every now and again it needs a bit of zing to make it come alive. The toadstools of sequins are my touch of zing as they draw the eye, giving you the balance of colour that is lacking.'

The ties of the lacings are made from painted silk cocoons, with ribbons, beads, crystals and pearls drawn up inside the cocoons.

The moths along the top of the bustline are made from sheers which were cut out individually with a soldering iron. This is to give that ethereal essence of the magic of the night, as all fairies need a little extra to make them fly!

121

Geneviève Attinger

Fabrics and threads are the chosen materials for Geneviève's artistic expression, somewhere between painting and sculpture; a palette of colours coupled with sensual, tactile materials, there to be manipulated.

Geneviève finds her inspiration in what she knows, what she looks at, what she reads, personal events, photos in magazines, news in the press… something read will give birth to an idea often linked to a theme related to women that will be interpreted expressing joy, hurt or revolution. Sometimes it's an object that is the source of inspiration, and it was thus for the series of nightshirts and petticoats.

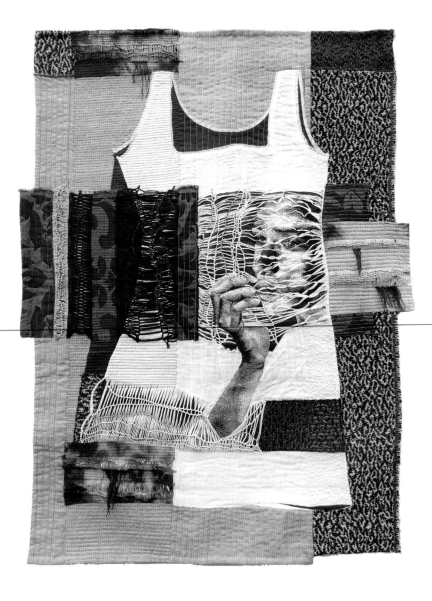

Tribute to the Past by Geneviève Attinger. Worked with cotton and silk: hand dyes, pulled-thread work, free-motion machine embroidery, machine piecing and quilting.

122

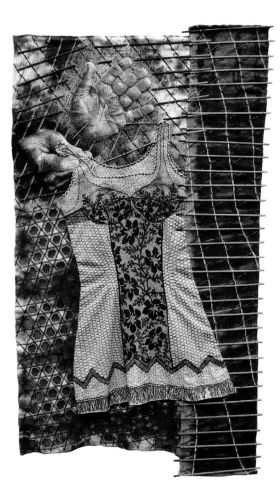

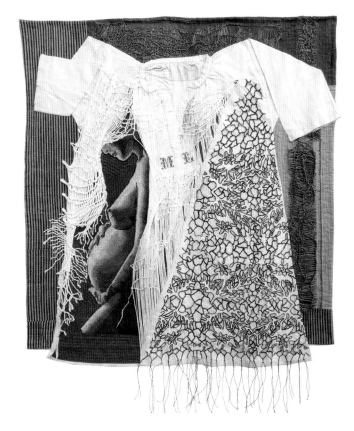

Above left: *The Fantasy Petticoat* by Geneviève Attinger. The transformation of a simple vintage petticoat into an object of desire! Made with cotton, hemp, wire and wood. The piece is hand dyed, discharged, free-motion machine embroidered, machine appliquéd and machine pieced.

Above right: *Profound Links* by Geneviève Attinger.

Genevieve sketches and draws the element at the heart of the work, the face or the part of the body. She then looks at her palette of fabric and cuts the pieces that will allow her to position the different values of the subject. Then, with free-motion machine embroidery Geneviève works to obtain a good representation that will define itself in the larger context of the work.

The layout is sketched beforehand and imposed by the subject, but the orientation that the image takes can cause this to evolve.

She dyes, bleaches and mistreats the fabrics, cutting, knotting or pulling out threads. These manipulations are not an end in themselves but a means of creating the story for which the threads and fabrics become her tools of expression.

She says 'I sew my story and the spectator reads his/her own story from that. The title, essential for me, will open the doorway a little towards a possible interpretation.' The past is present in everything, as with *The Fantasy Petticoat*. The person who made it and she who wore it are present. It's true in art and in life.

Conclusion

Throughout the book I have looked at different construction techniques with different materials and methods to help in the making of a corset, be it for display or for wearing. But by showing the work of artists who have addressed the issues, I hope you will also see a way of finding inspiration in your own experiences, in the experiences of others, in your imagination or in historical characters. Enjoy playing with different techniques to make wearable or unwearable art.

Try challenging yourself, alone or with others, perhaps in a group, to be inspired by corsets or underwear and to create and go as far as possible with your ideas. Working in a group can really get the inspiration flowing as everyone tries to do something creative with a bra, pyjamas, nightdress or knickers! Making wearable art, unwearable art or just underwearables can be meaningful, emotional, inspiring, conceptual, relieving and cathartic – or it can just be plain fun!

Acknowledgements

Let me say thank you to Batsford for accepting this, my sixth project, with them and producing a mouth-watering book, and to all the embroiderers, textile artists and artists who contributed to the book. Thank you all.

To all my regular students who really put their all into the group projects, as well as individual ones. I would like to thank Martine Amans, Catherine Melchior, Monique Joyeuse, Claudia Boucard, Catherine Delage, Paule Briande, Dany Pottier, Vonique Pierre, Roselyne Le Croq and Catherine Houchot for the pieces shown on page 70; all others are named individually for specific work.

Picture credits

Most of the photos were taken by Michael Wicks or Val Holmes.

Other picture credits are as follows:

Julia Triston's work by Steven Landles.

Geneviève Attinger's work by Geneviève Attinger

Karen Frosts' work by Elizabeth McLagen

Katherine Grimoldby's work by Kat Grimoldby

Viviane Fontaine's work by Viviane Fontaine

Helen Marchant's work by Rob Marchant

Suppliers

Art Van Go

The Studios

I Stevenage Road,

Knebworth

Hertfordshire SG3 6AN

Tel: +44 (0) 1438 814946

Email: art@artvango.co.uk

Website:www.artvango.co.uk

Sew Curvy

Lower Studio 26

Eynsham Park Estate

Cuckoo Lane

North Leigh

Oxfordshire

OX29 6PW

info@sewcurvy.com

www.sewcurvy.com

Vena Cava Design

(A UK-based mail-order corset and costuming

supply company)

www.venacavadesign.co.uk

Sewing Chest

The Old School

Walkerith Road

East Stockwith

DN21 3DG

www.sewingchest.co.uk

Habithat

1 The Bungalows

Furzehill

Chard

TA20 1AU

www.habithat.co.uk

Contributing artists' websites

Julia Triston

www.juliatriston.com

Kat Grimoldby

www.katgrim.com

Viviane Fontaine

www.vivianefontaine.ch

Geneviève Attinger

www.attinger-art-textile.odexpo.com

Val Holmes

textile-art-centre.com.fr

Further reading

Abrose, Bonnie Holt, *The Little Corset Book* (Costume and Fashion Press, 1997)

Barrère, Hubert and Boyer, Charles-Arthur, *Corset* (Rouergue Bibliothèque de Costume, 2011)

Betterton, Rosemary, *Intimate Distance: Women Artists and The Body* (Routledge, 1996)

Holmes, Val, *Creative Recycling in Embroidery* (Batsford, 2006)

Holmes, Val, *Collage, Stitch, Print: Collagraph Printing for Textile Artists* (Batsford, 2012)

Holmes, Val, *The Encyclopedia of Machine Embroidery* (Batsford, 2003)

Orback, Susie, *Fat is a Feminist Issue* (Paddington Press Ltd, 1978)

Orback, Susie, *Bodies* (Profile Books, 2009)

Saint Laurent, Cecil, *Histoire Imprevue des Dessous Feminins* (Herscher, 1986)

Salen, Jill, *Corsets: Historical Patterns and Techniques* (Batsford, 2008)

Shorter, Edward, *Women's Bodies* (Basic Books, 1982)

Sparks, Linda, *The Basics of Corset Building* (St. Martin's Griffin, 2005)

Steele, Valerie, *The Corset: A Cultural History* (Yale University Press, 2001)

Waugh, Norah, *Corsets and Crinolines* (Routledge/Theatre Art Books, 1954)

Index